ISLAND IN THE STORM

ISLAND IN·THE STORM

Sullivan's Island
and Hurricane Hugo

JAMIE W. MOORE AND DOROTHY PERRIN MOORE

THE
History
PRESS

Published by The History Press
Charleston, SC 29403
www.historypress.net

Front cover photo: The Ben Sawyer Bridge after Hurricane Hugo. *Courtesy Emergency Management Division, Charleston District, Army Corps of Engineers.*
Back cover photo: Surveying the damage. *Courtesy of the authors' personal collection.*

First published 2006
Second printing 2015

Manufactured in the United States
ISBN 978.1.59629.143.0

Library of Congress Cataloging-in-Publication Data
Moore, Jamie W.
Island in the storm : Sullivan's Island and Hurricane Hugo / Jamie W
Moore and Dorothy Perrin Moore.
p. cm.
Includes bibliographical references.
ISBN 978-1-59629-143.0
1. Sullivan's Island (S.C. : Island)--History--20th century. 2. Hurricane
Hugo, 1989. 3. Hurricanes--South Carolina--Sullivan's Island
(Island)--History--20th century. 4. Community life--Sullivan's Island
(Island)--History--20th century. 5. Disaster relief--South
Carolina--Sullivan's Island (Island)--History--20th century. I. Moore,
Dorothy P. II. Title.
F277.S77M66 2006
975.7'91--dc22
2006016762

CONTENTS

DEDICATION

The rich history of Sullivan's Island and the Isle of Palms frames the setting for the voices of the islanders as they struggled with the disruption that Hurricane Hugo brought. For many, with homes washed away and property badly damaged, life would not be easy. The sense of loss was everywhere. Flowers, plants and trees lay twisted and crippled. Cedars were crushed and bent. Pines stood forlorn. The birds had disappeared. But as everything else changed, the island palmettos with their waving fronds seemed to defy the high winds and seas. And Hugo had brought with it from Cape Verde a symbol of new hope: a delicate African pink flower. Each May, on the way to the beach, you can find the radiant blooms sparkling in the warm sun.

During our research we were continually impressed with the numerous stories of the contributions to the recovery made by the hardworking, conscientious public employees and civil servants—municipal, state and federal—whose efforts so often go unrecognized. We all owe them a great debt, and this book is, in part, a thank you.

Our book is dedicated to all of those who live in the potential paths of great storms and to all the islanders. We also dedicate the book to the loving memory of our parents Belle and William Jamie Moore, who loved Sullivan's Island so much, and pass it on, with love, to Jamie and Anne Moore and our three grandchildren, James Sullivan, Daniel Wallace and Justin Laurance, of Long Island, New York.

ACKNOWLEDGEMENTS

The research for this book would not have been possible without the assistance of Cathy Haynes, director of the Charleston County Emergency Preparedness Division, historian Rick Hatcher at the Fort Sumter National Monument and Marlene Judy and Derald McMillan of the Emergency Management Division, Charleston District, U.S. Army Corps of Engineers. Our thanks to Curtis Brice, resident maintenance engineer for bridges, South Carolina Department of Transportation, for helping clear up the mystery of the Ben Sawyer Bridge. The story would have been incomplete without the cooperation of the many public officials across the Lowcountry who appear in the text and the residents of Sullivan's Island. We gratefully acknowledge the generosity of Irene Nuite Lofton, a former neighbor, for permission to quote freely from *The Broken Bridge*, her collection of poems written during the year after Hurricane Hugo.[1] At The History Press we were in the capable hands of managing editor Kirsty Sutton, editorial coordinator Julie Foster, commissioning editors Jason

Chasteen and Jenny Kaemmerlen, sales and marketing coordinator Brittain Phillips and editorial assistant Hilary McCullough. The 1990 survey and subsequent research was supported by a series of grants from The Citadel Development Foundation.

INTRODUCTION

My life is divided into "before" and "after" Hugo and will likely remain so for a long time.

Sullivan's Island resident

The town of Sullivan's Island annually issues a Hurricane Preparedness Guide that offers in some twenty-five pages a variety of preparedness information. The first sentence in the most recent edition reads, "The purpose of this guide is to provide an introduction to hurricane preparedness for the residents and property owners of Sullivan's Island." The most important word in the sentence is "introduction."

This book tells the story of the experiences of the people of Sullivan's Island during and after Hurricane Hugo, which struck the South Carolina coast on the night of September 21–22, 1989. It profiles a community of some 437 families and 1,603 people who lived on the barrier island when it was crossed by the hurricane's eye

and submerged by the storm surge. None of the 923 buildings on the island escaped damage. More than 60 were totally destroyed.

In 1990, we obtained the first in a series of grants from The Citadel Development Foundation to undertake a comprehensive survey of what people had gone through and how they felt. More than 40 percent of the residents and property owners we were able to contact completed the lengthy survey questionnaires inquiring into their experiences on returning to the island and during the long period of recovery and reconstruction. Readers interested in the methodology and details of the survey will find that information in Appendix 1.

Hugo was the worst hurricane to batter South Carolina since 1872 and the strongest to strike the United States in twenty years. It hit the South Carolina coast as a Category 4 with the center of Hugo's eye crossing Sullivan's Island near midnight. For nearly an hour, the ocean waters covered the island.

Each barrier island resident has a story. Ours is special only in the sense that it illustrates how quickly and how much life changed.

Thursday–Friday, September 21–22.

For the past two days we have been boxing and packing, photographing and videotaping and doing everything else we could think of to get ready. Always in the background the television and radio told us of the oncoming storm. A hurricane warning was issued Thursday for the entire South Carolina coast and a mandatory evacuation of the barrier islands is now in effect. We finished taping the last window at 3:00 a.m. Friday morning and were up before 5:00. We could hear a continuous rumble of thunder and see the high sky lit by flashes of lightning from a line of storms far out at sea. We pulled the main breaker, looked around and wondered if we would see the house again. Friday night in Columbia we learned that Hugo

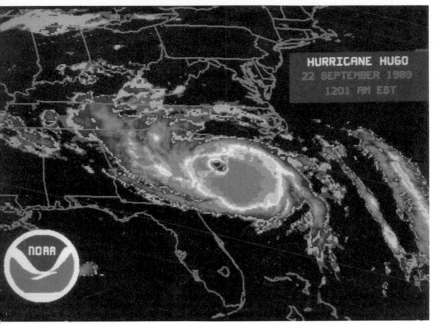

Satellite image of the eye of Hurricane Hugo crossing Sullivan's Island at 12:01 A.M., September 22, 1989. *Courtesy NOAA.*

was striking Charleston with winds of one hundred thirty five miles per hour and destroying everything in its path. Great sheets of water hurled against the large plate glass of the single window as we watched the showers of sparks and the lights of the city go off as the power grid went down.

Saturday, September 23.

The news media have been unanimous in reporting the great destruction on the barrier islands. On Friday we picked our way out of Columbia heading for Greensboro, North Carolina,

where we took our elderly parents to stay with relatives. No traffic lights were working and limbs and debris were everywhere. By telephone we learned from relatives in Arkansas that a flyover of Sullivan's Island had been broadcast. They thought our house was still standing. We returned to Columbia and packed the car with water and everything we could think of that we might need and started back to Mt. Pleasant. All up and down the interstate corridor, on both sides as far as the eye could see, there were severed pines. It was as if the hurricane had followed the evacuation straight up the highway. As we approached Charleston, we observed the mighty force of the storm by the toppled pine trees lining the highway and street lights and telephone poles bent at crazy angles. We crossed over the Cooper River Bridge to find our parents' apartment building badly battered. The roof and siding of the apartment upstairs had been breached and the back windows of their apartment had been smashed. Water had poured in. Everything was soaked, but the apartment could be made habitable. We began to make camp.

We were able to connect with our friends Jeanette and Jim Harper. They had roughed out the hurricane through a horrifying evening in the house of friends in Mt. Pleasant. It had shaken as if it would topple and massive trees crashed and banged outside. The first floor of their own house in Old Mt. Pleasant was covered in a deep layer of pluff mud. They had moved furniture upstairs before the storm and would be living there for the duration of cleanup and repair. We joined them at the home of Anne and Billy Suttle for breakfast, a charcoal grill feast of fresh oranges, shrimp, vegetables and more from the no-longer-electric refrigerator. Jeanette, in defiance of the power of the storm, wore pearls to breakfast to celebrate the triumph of survival.

Introduction

Postlude of a Storm

The tympany of wind and wave
Dies
Desolate silence
Hangs over the barren land
Until a lone bird sings
In a broken tree

Irene Nuite Lofton

I.
THE ISLAND

The island is a very singular one. It consists of little else than sea sand, and is about three miles long. Its breadth at no point exceeds a quarter of a mile. It is separated from the main land by a scarcely perceptible creek, oozing its way through a wilderness of reeds and slime, a favorite resort of the marsh-hen. The vegetation, as might be supposed, is scant, or at least dwarfish. No trees of any magnitude are to be seen. Near the western extremity, where Fort Moultrie stands, and where are some miserable frame buildings, tenanted during summer, by the fugitives from Charleston dust and fever, may be found, indeed the bristly palmetto; but the whole island, with the exception of this western point, and a line of hard, white beach on the seacoast, is covered with a dense undergrowth of the sweet myrtle so prized by the horticulturists of England. The shrub here often attains the height of fifteen or twenty

feet, and forms an almost impenetrable coppice, burthening the air with its fragrance.

Edgar Allen Poe[2]

When the English settlers of Charles Towne sailed upriver to anchor in a tidal creek hidden from the harbor in April 1670, they were few in number and intruding into lands claimed by Philip of Spain, ruler of Europe's largest and wealthiest state and sovereign of a global empire that stretched to the fortress outpost at nearby St. Augustine. The colonists selected an area that they had previously scouted for the settlement they would christen Albemarle Point: elevated, densely timbered ground protected on one side by an inaccessible marsh and bounded by a steep creek bed on the other, that offered a fine defensive position. The first thing they did on landing was to move the ship's cannon ashore. They began cutting logs for a defensive palisade. In time, they dispatched a lookout to the barrier island on the north side of the harbor to keep an eye out for a Spanish attack. An Irish soldier of fortune and experienced in military affairs, the lookout was well qualified to command the coastal watch cannon. But he was also known to his fellow colonists as "dissentious," "ill-tempered," "troublesome" and "unfit," and according to the philosopher John Locke, confidant of Colony Proprietor Lord Ashley Cooper, "an ill-natured buggerer of children." From Captain Florence O'Sullivan, Sullivan's Island would take its name.[3]

After relocating to the Charleston peninsula, the Colonial Assembly, in 1700, authorized the construction of a brick watchtower and lighthouse on Sullivan's Island. There is some evidence to infer that the Assembly ordered the entire maritime forest cut down to provide incoming mariners with an unmistakable landmark until the watchtower was erected.

The Island

The early eighteenth-century development of Sullivan's Island was shaped by powerful economic and social forces. Repeated deadly waves of yellow fever and smallpox swept the colony in the early years of the century and in 1707 the city fathers reacted. Rejecting the explanation of the Reverend Gideon Johnston, rector of St. Philip's Church, that the epidemics were "God's judgment on the sinful people of Charles Town" in favor of a policy of building a quarantine facility, they authorized construction of a "pest house" on Sullivan's Island to isolate suspected cases of illness aboard arriving ships. Construction of the quarantine facility was also spurred by the dramatic increase in slave traffic as a result of the African-introduced methods of rice cultivation that energized Lowcountry plantations with a new money crop. A statute enacted in 1744 made the quarantine site the official and exclusive entry point for "all Negroes from the coasts of Africa or elsewhere." Perhaps as many as five hundred thousand slaves arrived in South Carolina between 1710 and 1775 and more than eighty-nine thousand passed through or served quarantine on Sullivan's Island. The exact numbers are nearly impossible to calculate, but as the historical marker at Fort Moultrie commemorates, Sullivan's Island became "the Ellis Island for black America."[4]

This is Sullivan's Island. A place where.. Africans were brought to this country under extreme conditions of human bondage and degradation. Tens of thousands of captives arrived on Sullivan's Island from the West African shores between 1700 and 1775. Those who remained in the Charleston Community and those who passed through on this site account for a significant number of African–Americans now residing in these United States.

The island also took its place in folklore. In 1718, after the citizens of Charles Town decided that the pirates they had been sheltering and from whom they had profited had gotten out of hand, they sent an expedition to destroy them. One would escape, briefly. For ten days Stede Bonnet hid out on Sullivan's Island before being captured, swiftly tried and executed.

The defensive importance of Sullivan's Island resurfaced prominently after revolutionary fever swept Charles Town in 1775. On June 28 and 29, 1776, at the west end of the island, Regulars and South Carolina militia under the command of Colonel William Moultrie, fighting from the rude, unfinished and strategically placed palmetto log fort newly named "Fort Sullivan" that dominated the ship channel into Charleston Harbor, successfully out-dueled the guns of nine British warships. The revolutionary defenders were certain that they were fighting to repel an invasion fleet and well understood that they were risking all to oppose the Crown. But the British aims were something else entirely. Commodore Sir Peter Parker and General Sir Henry Clinton had been looking for Loyalists in the Carolinas, and not finding any, decided to pick on what they thought was a soft spot to teach the Rebels a lesson before heading to their prearranged rendezvous with Sir Henry Howe in New York. But both the naval and land operations were poorly planned and executed. British frigates under Parker's command were boldly ordered into a harbor that this fleet of the Royal Navy knew nothing about. Three of the frigates ran aground in the channel and one could not be refloated. In the ensuing engagement, the British cannon fire was either soaked up by the palmetto and sand fort or sailed harmlessly overhead to saw down trees while American fire from Fort Moultrie raked British ships. At Breach Inlet, at the east end of the island, Colonel William Thompson's men faced some twenty-two hundred British troops. But after landing his force on Long Island and pitching camp in sight of

Breach Inlet, General Clinton had occupied their time by marching them in full uniform in the Carolina heat, so when he finally discovered the waters were not a foot and a half deep but seven feet, he had to scrap his original plan to march his force across Breach Inlet. Clinton's next choice, an action he did not bother to coordinate with Parker, to send armed schooners against Thompson's fortification and land his infantry by boat, proved to be an equally bad idea. American artillery raked the schooners and riflemen and stopped the infantry in their tracks.[5]

When the British returned to Charleston in February 1780, they carried out a professional and highly successful combined operation that resulted in the greatest American defeat of the Revolution. But the American victory in 1776, however attained, was not without significance. Nearly coinciding with the promulgation of the Declaration of Independence, it said something about the ability as well as the willingness of Americans to continue an armed struggle that had begun at Lexington and Concord, Massachusetts, fourteen months earlier. For his part, after being apprised of an official investigation that concluded that the effort had been a military disgrace, King George III offered the stiff upper lip remark that while he did not feel his forces had dishonored themselves, he would have been pleased if the attack had not been attempted.[6]

In the aftermath of the American Revolution, the South Carolina State Legislature, in 1787 and 1791, invalidated all previous land grants and appropriated Sullivan's Island for public purposes. From this time forward, building on the island would be only by license and permission would be granted with the understanding that any residences built would be "given up" to the government if the situation required. In law, the houses constructed on Sullivan's Island were privately owned but the land on which they stood was not; lots were leased from the state for periods varying from fifty to seventy-five years. In practice, because families transferred ownership down

through the generations as if they owned the properties free and clear and as the state kept the number of lots for lease capped at five hundred, Sullivan's Island grew slowly as a community of single-family residences.[7] The lease system would not be replaced with fee-simple titles until the twentieth century. By then the exclusion of large-scale commercial development had been ingrained into the island's character.

The global wars of the European superpowers that exploded in the aftermath of the French Revolution and the threats to American ships and seacoast towns that continued into the era of Napoleon saw the construction of new and more elaborate coastal fortifications. Congress approved a second fortification on Sullivan's Island in 1794 and after a hurricane in 1804 damaged that work beyond repair, in 1807 authorized the construction of a more modern replacement. This brick and mortar "third" Fort Moultrie was essentially completed by 1809. It saw no action in the War of 1812, but after that conflict Congress looked back at the ease with which the British had launched their attacks on the North American mainland and, resolving to prevent any reoccurrence, created a Board of Engineers for Fortifications, instructed it to prepare plans for defensive works and between 1821 and 1861 appropriated over $31.4 million for "arsenals, armories and fortifications" to protect the American coastline. The plan to protect the city of Charleston included an upgraded Fort Moultrie and a new fortification to be built atop a shoal forming in Charleston Harbor about a mile south of the peninsula.

The construction of Fort Sumter changed the topography of Sullivan's Island. For reasons no one could explain, the island's western end had begun eroding severely, and by 1831 Fort Moultrie sat only two feet above the high tide mark, the foot of its walls occasionally washed by storm-stirred surf. If the fortification with its fifteen-foot-high brick walls, forty guns and

capacity for three companies of soldiers were to be a component in a Charleston Harbor defense system centered at Fort Sumter, something had to be done before it was completely undermined. In 1837, the U.S. Army Corps of Engineers began the first of several major land reclamation programs. The most successful was the construction of a breakwater jetty extending from the Sullivan's Island shore to nearby Drunken Dick Shoal. Designed to interrupt the sand scour of the harbor current, and costing more than $100,000, the jetty proved a major success. By 1845, the beach had moved outward more than one hundred yards. In the Mexican War, the expanded Fort Moultrie would serve as a staging area for departing troops. [8]

It was during these years that Fort Moultrie sheltered two of its most famous residents. Private Edgar Allen Poe, who had falsified his age and enlisted in the army under the alias Edgar A. Perry, arrived in 1827 when Battery H of the First Artillery was transferred from Fort Independence in Boston Harbor. During the next year, Poe soaked up enough of the atmosphere to use a geographically altered landscape of Sullivan's Island fifteen years later as a setting for pirate codes and buried treasure in *The Gold Bug*.[9] Osceola, chief of the Seminoles, captured in Florida in an act of treachery in 1837, arrived for his imprisonment at Fort Moultrie in 1838, to die shortly afterwards.

By the early nineteenth century, a permanent community had built up on Sullivan's Island near Fort Moultrie. It consisted mainly of families who had originally started coming to the island to escape the heat and plagues of Charleston in the summer plus others with connections to the fort. In 1817, these leasehold residents incorporated a town under the name "Moultrieville." One of the new government's first acts was the passage of a statute prohibiting anyone from bathing "openly and naked" between sunrise and two hours past sunset.[10]

By 1860, as tensions between North and South reached a breaking point, Fort Moultrie was in such disrepair that the small garrison was limited to performing such housekeeping duties as shooing out the cows that had climbed the sand dunes at the walls to graze inside. Designed to defend Charleston Harbor from attack from the sea, not to defend itself against an attack from the land side, the fort was vulnerable and the garrison at risk. In the late afternoon of December 26, 1860, Major John Anderson quietly ordered his eighty-two-man command to spike the cannon and row out to Fort Sumter, where construction was nearing completion. The action triggered a series of events that culminated on April 12, 1861, in the Confederacy firing the first shots of the Civil War in the bombardment of Fort Sumter.

In the early months of the fighting, Union forces occupied or bottled up every Southern port except Charleston and Wilmington. For two years, the Confederate defenses of Charleston, including a greatly strengthened Fort Moultrie and a series of artillery emplacements along the length of Sullivan's Island, beat off every attempt at assault. After 1863, Union forces opted for a strategy of siege and maintained a large blockade fleet in the harbor. In a footnote that would have no bearing on the outcome of the war but would itself become historic, in August 1864, the Confederate ship *Hunley* departed Sullivan's Island at Breach Inlet to attack and sink one of the blockading ships, the Union sloop-of-war *Housatonic*. It was the first successful sinking of a ship by a submarine. The *Hunley* went down with all hands shortly after the engagement, not to reappear until it was successfully excavated, rising to the surface in the waters off Sullivan's Island in August 2000.[11]

Between the end of the Civil War and the turn of the century, Sullivan's Island was the site of two major federal construction projects and the beneficiary of an extensive private real estate development. Harbor improvement was the first project. The

24

entrance to Charleston Harbor, a little more than a mile and a quarter wide, lies between Sullivan's Island and Morris Island. Their configuration forms the spout of a gigantic funnel through which the Atlantic Ocean pours. At flood tide, the incoming currents pile up along the shore before finding their way inland to deposit the sand they carry in a gigantic bow-shaped sandbar that stretches across the harbor. For more than three hundred years, the scour of the exiting ebb tides had maintained several constantly shifting ship channels through the sandbar barrier, an act of nature that had enabled colonial Charleston to become America's third largest city and most important Southern port. But by the 1850s, the harbor channels had begun to fill with sand and Charleston's commercial future was in danger. Several small dredging projects were attempted in an effort to clear the channels during the decade, but they were ineffective.

The successful harbor construction project was carried out under the command of Colonel Quincy A. Gillmore. He had been a member of the commission that had surveyed the Charleston bar to recommend improvement before the Civil War and commanded the Union forces conducting the siege of Charleston that hammered the city. In 1869, Gillmore was placed in charge of coastal defenses from the Cape Fear River to St. Augustine and the next year he became the area's supervising engineer for surveys of rivers and harbors. Following the elections of 1876, the Charleston Chamber of Commerce petitioned Congress for $10,000 for a Corps of Engineers survey of the harbor. Gillmore did not wait for the funding to materialize but at his own discretion shifted money from other projects to carry out the survey and then designed a novel, far-reaching project to reestablish Charleston as a major port. Not stopping there, Gillmore went to Washington to lobby for the Charleston Harbor project and even helped maneuver a $200,000 appropriation for the work through the House of Representatives.

Gillmore's design used the forces of nature. Two jetties were constructed, the southern springing from Morris Island and the northern from Sullivan's Island, both curving toward each other until, at a point about 9,000 feet from Sullivan's Island and 14,000 feet from Morris Island, the jetties straightened to a parallel about 2,900 feet apart. The genius of Gillmore's design lay in constructing the center, deep-water and the jetty portions near the shores below the surface of the water. This allowed the flood tides to bring in their 5.1-foot prism of water but trapped the powerful ebb tide currents between the jetties and harnessed the power of their 3.66 trillion cubic feet of moving water to scour the bottom to keep the channel clear. Begun in 1877 and essentially completed by 1895 at a cost of approximately $3.9 million, the project proved a complete success. By interrupting the southward littoral sand drift along the coast, the jetties also dramatically slowed erosion at the eastern end of Sullivan's Island.[12]

The second great federal project was the construction of a modern coastal fortifications complex at Fort Moultrie. It took from 1865 to 1884 for the military to work out the elements of a new defense system to protect over four thousand miles of American coastline and until 1888 before Congress appropriated the money to begin building it. Given the size of the United States, its rapidly growing population and even more rapid industrialization, the possibility of a successful foreign invasion was too absurd to be seriously entertained. The argument for a new coastal defense system was therefore based on a perceived need to be able to prevent foreign fleets from approaching near enough to bombard cities, extract ransom or practice coercive diplomacy. Great Britain was considered the most likely aggressor. For their part, British planners never considered a war of aggression, but did think a war might result from American aggression—after all, the United States had a "popular government and was suscep-

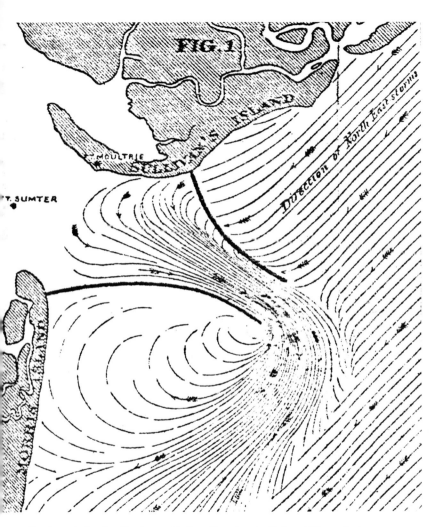

The jetty design for Charleston Harbor. *Drawings in Quincy Gillmore's plan for the improvement of Charleston Harbor. Reproduced in Jamie W. Moore,* The Lowcountry Engineers: Military Missions and Economic Development in the Charleston District.

tible to emotional outbursts and erratic actions"—or intolerable actions that impugned British honor.[13]

The main component at Fort Moultrie, where work started in 1895, consisted of the construction of emplacements and supporting elements for three types of artillery designed to engage battleships at sea. Two twelve-inch rifled guns capable of firing a half-ton projectile up to eight miles on a relatively flat trajectory were emplaced at Battery Huger. One was a disappearing gun, meaning it stayed sheltered behind earth and concrete barriers to be serviced and loaded and then lifted itself up over the parapet for firing. The other was mounted *en barbette*, i.e., fixed in its position on top of the fortification. At Battery Jasper, four ten-inch guns with a range of about nine miles were mounted on hydraulically and electrically operated disappearing gun mounts. From the fortified deep pit constructed at Battery Capers, four twelve-inch rifled mortars were able to hurl a seven-hundred-pound projectile up to nine miles while remaining safely sheltered.[14]

The large-scale commercial promotion benefited Sullivan's Island in passing, literally. A functioning seaside resort since the 1820s, by the 1850s, with the construction of the Moultrie House, a luxury hotel just east of Fort Sumter, complete with a horse-drawn cable car for the short ride from the cove dock to the front door, Sullivan's Island had become an increasingly popular destination for wealthy vacationers, summer residents and beach day-trippers. In the Civil War, Sullivan's Island had been placed under martial law and civilian residents were barred from the island. The wartime bombardments destroyed the pre-war hotel and cottages, but afterwards many cottages were rebuilt, new ones were added and in 1881 the three story, 112-room beachfront New Brighton Hotel was built in the middle of Sullivan's Island. With elegant facilities, bathhouses, an entertainment hall capable of seating three hundred people and a branch of the railway line dedicated for the exclusive

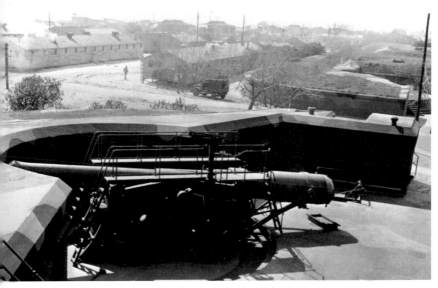

Gun No. 1, Battery Jasper, taken between 1943 and 1945. *Courtesy U.S. Army, Files National Park Service, Fort Sumter National Monument.*

use of its guests, the hotel proved to be a major attraction, and around it grew up a new community, Atlanticville.[15]

The coastal population of the United States was not large until the late nineteenth century, when steam ferry boats, railroads and electric trolley cars made possible the development of seaside resort towns. Because of the restrictions on land use, Sullivan's Island could not be commercially developed, but the largely uninhabited barrier island to the east just across Breach Inlet could be. In 1898, following a pattern that others had proved successful elsewhere, Dr. Joseph S. Lawrence, who had introduced the electric trolley to Charleston, and a consortium of investors moved rapidly forward with plans to construct a large seaside resort. They first changed the name of largely undeveloped Long Island to the more marketable name of the Isle of Palms and then, in rapid succession, purchased an existing ferry service, created a new company (the

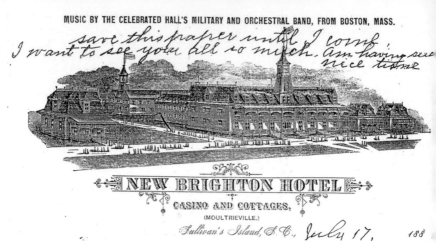

MUSIC BY THE CELEBRATED HALL'S MILITARY AND ORCHESTRAL BAND, FROM BOSTON, MASS.

save this paper until I come; I want to see you all so much. Am having such nice time

NEW BRIGHTON HOTEL
CASINO AND COTTAGES,
(MOULTRIEVILLE.)
Sullivan's Island, S.C., July 17, 188

New Brighton Hotel Letterhead. *Courtesy Marshall Stith.*

Charleston and Seashore Railroad) and began to knit together an integrated transportation system to move people from Charleston to the Isle of Palms. Eventually, beachgoers were greeted by a resort complex complete with seashore hotel, restaurant, grand pavilion, bathhouse, a "gentlemen's clubhouse," a large Ferris wheel originally built for the 1892 Chicago World's Fair and "a steeple chase imported from Coney Island."[16]

Getting to the coastal resort was a trip. From Charleston to Mt. Pleasant, one took the ferry. There, a line of electric trolley cars waited. They traveled in pairs, the car with the electric motor pulling a trailer, except for the last car, which ran singly. At the other end of the line, the cars were re-coupled; the single car last in line would pick up a trailer, and the car in the front would make the return trip by itself. The line carried passengers through the village, across Cove Inlet to Sullivan's Island via a trestle swing bridge that opened for maritime traffic, traversed the length of Sullivan's Island by way of today's Middle Street and Jasper Boulevard, crossed over a trestle bridge at Breach Inlet to the Isle of Palms and continued to the beachfront. The trick was to hurry to board the first cars in line,

Draw Bridge between Mount Pleasant and Sullivans Is.

Electric trolley and trailer. *Courtesy Marshall Stith*.

which were express, and not the locals, which would make as many as twenty stops in Mt. Pleasant and Sullivan's Island. The complete ferry and express car trip could be as short as an hour each way. Built to develop the Isle of Palms, the trolley line gave Sullivan's Island a connection to the mainland and also an enduring legacy in the form of the trolley station stops that in time became the station-numbered cross streets.

Access to the barrier islands was interrupted in 1924 when, after a series of reorganizations, the combination of financial complications and demands for free ferry service finally dissolved the trolley and resort enterprise and the sheriff's office seized the ferry boats. The connection was not reestablished until Charleston County remodeled the Cove Inlet Bridge between the Old Village in Mt. Pleasant and Station 9 on Sullivan's Island for automobile traffic. Automobiles replaced the trolley line across Breach Inlet in 1926. In 1929, the spectacular John P. Grace Bridge linked Charleston and Mt. Pleasant. And in 1945, the new Ben Sawyer swing drawbridge replaced the old Pitt Street Bridge over the newly dredged Intracoastal Waterway.[17]

Sullivan's Island indirectly benefited from the federal expenditures that poured into Lowcountry South Carolina in increasingly

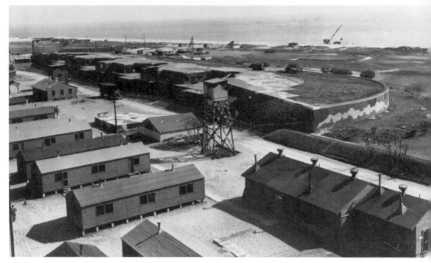

Above: Battery Jasper I and II showing four disappearing ten-inch rifles. Taken between 1943 and 1945. *Courtesy U.S. Army, Files National Park Service, Fort Sumter National Monument.*

Below: 155-millimeter gun on a beachfront mount at Marshall Reservation. Taken between 1943 and 1945. *Courtesy U.S. Army, Files National Park Service, Fort Sumter National Monument.*

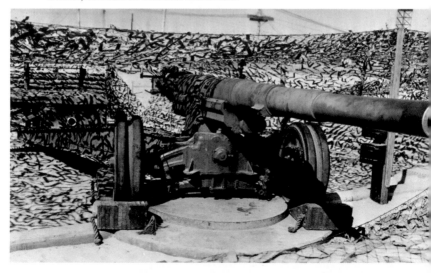

large amounts during the first half of the twentieth century. Savvy political maneuvering had succeeded in convincing the United States Navy to relocate a naval station to Charleston in 1902, and the First World War brought a substantial increase in base funding. After the war, the naval station continued to grow, but the real impact came with the defense buildup preceding American entry into the Second World War. A few numbers tell the story. In 1940, the yearly per capita income in South Carolina totaled $301. In Charleston County, it was $457. Between July 1, 1940, and June 30, 1941, federal expenditures in Charleston County equaled $857 for every man, woman and child. The navy yard became the third largest industry in the state and Sullivan's Island the home of the growing blue-collar population that worked there.[18]

During the Second World War, new defense structures rose all over Sullivan's Island: a harbor control and command center at Fort Moultrie, gun emplacements along the beachfront all the way to Breach Inlet and anchors for the submarine nets protecting Charleston Harbor and the navy base. On the east end of the island rose barracks, support services, a 155-millimeter gun emplaced on the beach and the dominating Construction 520. Informally referred to as Battery Marshall, the huge earth-covered, steel-reinforced concrete structure housed two twelve-inch rifled guns, powder magazines and the command and control center.

The closure of Fort Moultrie in August 1947 caused some economic disruption, but in the long term provided the island with an important resource in the form of land that was transferred first from the federal government to the state and then to the Sullivan's Island Township.

In 1962, Sullivan's Island acquired its most dominant landmark, the triangular-shaped, 165-foot high lighthouse at the Coast Guard station, complete with elevator. The lighthouse, with the strongest light in the western hemisphere and the second most powerful in

Front view of Construction 520 showing the plotting room and two twelve-inch guns. Taken between 1943 and 1945. *Courtesy U.S. Army, Files National Park Service, Fort Sumter National Monument.*

the world, was fully automated in 1982. For many years, it remained the last manned lighthouse on the U.S. coast.[19]

In the years after World War II, the relatively stable, largely blue-collar, naval-base-connected, year-round population, which was augmented in summer by off-island families who owned vacation houses, was enlarged with a gradual influx of new arrivals, the largest number consisting of urban professionals for whom Sullivan's Island was an ocean-side suburb easily accessible from Charleston. By 1989, the island's year-round resident population totaled 437 families and 1,603 people. But while this newer and larger community was somewhat different, the arrivals had not changed the basic village character, primarily because the newcomers enthusiastically joined with earlier residents to preserve what had attracted them in the first place. An effort in 1973, for example, to build a condominium at Breach Inlet stirred up more than 250 protesters, an anti-commercial development consensus that enabled town officials to strengthen the existing municipal prohibitions against subdividing lots, expanding the two-block-long business district or constructing high-rise or multiple family dwellings. Unlike the more development-oriented South Carolina communities of Myrtle Beach, Kiawah, Seabrook, Hilton Head and the Isle of Palms, Sullivan's

Island deliberately did not bloom commercially. In 1989, *Parents Magazine* rated Sullivan's Island as one of the four most desirable places in the United States to rear children.[20]

Bridges had become the dominant local political issue. On the rapidly developing Isle of Palms, new resorts, a rising year-round population and increasing numbers of beach day-trippers to the more commercial beachfront had increased the traffic across Sullivan's Island. From the metropolitan Charleston area came new demands for easier access to the beaches. Barrier island residents spoke of the need for a second evacuation route in case of a hurricane. Everyone anticipated even greater population and increased traffic flow. To meet future needs, the South Carolina Highway Department recommended replacing the Ben Sawyer drawbridge with a fixed span structure and widening Jasper Boulevard, the main thoroughfare across Sullivan's Island; in 1982 funds for the project became available.

Hotly debated political issues had always aroused Sullivan's Island residents against perceived external threats. In 1973, islanders had vigorously and successfully contested the plans of the National Park Service to tear down cottages to construct "a sense of arrival" to the newly erected Fort Moultrie historic monument commemorating coastal defenses. But on the bridge issue, the island was split. For many, the highway department's plan would lead to development and change the character of the island. Others saw a fixed span bridge as providing a safer emergency evacuation route. In September 1982, by a 4–3 vote, the Sullivan's Island Town Council rejected the Highway Department's proposal. The more than one hundred residents who had packed into the town hall gave the council a standing ovation.[21] State law required the consent of the local township for bridge construction, so even though Mt. Pleasant and the Isle of Palms endorsed the project, the action of Town Council blocked construction. Round two commenced when

strong Highway Department lobbying prodded the South Carolina Legislature to enact special legislation that statewide would allow the highway department to proceed with its road and bridge construction plans even if a local government did not approve. Listening to the near-unanimous voice of the people registered in well-attended town hall meetings, the Sullivan's Island Township hit back with a lawsuit and eventually won in the South Carolina Supreme Court a judgment that nowhere in the state could a bridge be built within corporate limits without the consent of local government.

Attention now shifted to the alternative of constructing a new fixed span between the mainland and the Isle of Palms—something most Sullivan's Island residents, whatever their other differences, had favored all along. But for reasons similar to those that had motivated Sullivan's Islanders to defend the Ben Sawyer drawbridge, many Isle of Palms residents opposed the connector project. With voters divided on the issue, in mid-September 1989, the Isle of Palms Town Council scheduled an advisory referendum and a majority of the council pledged in advance to abide by the results.

The outcome of the referendum on the Isle of Palms, held on September 19, and the futures of both barrier islands would now be influenced by the storm that had already formed in the Atlantic.[22]

II.
THE STORM

Looking over the public advisories, it is noted that from 2200 UTC on the 20th to 2200 UTC on the 21st, the highest sustained winds increased from 105 mph to 135 mph. During this same period, the wind forecast contained in all of the public advisories was "little significant change in strength is likely." It is important for users of National Hurricane Center products to appreciate the limitations in tropical cyclone intensity forecasting, as here is a category four hurricane on the Saffir/Simpson Scale during the 30 hours prior to landfall.[23]

Miles Lawrence, Preliminary Report Hurricane Hugo
10–22 September 1989
(National Hurricane Center, November 15, 1989)

The Beaufort Wind Scale, devised in 1805 by British Rear Admiral Sir Francis Beaufort from his observations of the effects of the wind, explains how the wind can be seen. To paraphrase, on land, at four to seven miles per hour, leaves rustle and you can feel the light wind breezes on your face. Between eight and twelve miles per hour, small twigs move constantly. From thirteen to eighteen miles per hour, moderate breezes swirl loose paper around corners. Leafed out trees begin to sway when the winds reach nineteen miles per hour. At twenty-five miles per hour, large branches move and telephone wires whistle. Above thirty-two miles per hour, walking becomes inconvenient. At thirty-nine miles per hour, winds reach tropical storm strength, walking is difficult and the storm damage to trees can be observed. At forty-seven miles per hour and above, buildings begin to experience damage. Above fifty-five miles per hour, trees are uprooted and structural damage can be considerable. Above sixty-four miles per hour, the winds reclassify themselves as a tropical storm. When the winds exceed seventy-four miles per hour, hurricane conditions exist.[24]

Hurricane intensity is measured by the Saffir-Simpson scale, formulated in 1969 by Herbert Saffir, a consulting engineer, and Dr. Bob Simpson, director of the National Hurricane Center. In a Category 1 hurricane, where winds are between 74 and 95 miles per hour and tides rising four to five feet above normal are accompanied by some coastal flooding, the destruction primarily results from wind damage to mobile homes, shrubbery and trees. In a Category 2 hurricane, wind speeds reach 96 to 110 miles per hour, roofs, doors and windows are damaged and tidal flooding reaches six to eight feet. In a Category 3 hurricane, as the 110- to 130-mile-per-hour winds destroy mobile homes and small residences and utility buildings experience structural damage, tides nine to twelve feet above normal intrude inland, undermining and destroying

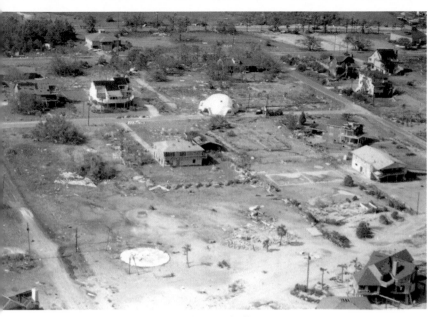

Aerial view of the destruction at the Marshall Reservation, Station 30, Sullivan's Island. *Courtesy Charleston County Emergency Preparedness Division.*

structures and damaging others with floating debris. In a Category 4 hurricane, the 131- to 155-mile-per-hour winds tear away roofs and collapse building walls while storm surges ranging from thirteen to eighteen feet cause major beach erosion and widespread inland flooding. In a Category 5 hurricane, with winds greater than 155 miles per hour and tidal surges over eighteen feet, the damage increases significantly.[25]

There is some hurricane risk anywhere along the coast. From 1900 to 1999, in any given year, the probability that a Category 3 storm or above would strike the East Coast was 31 percent. (The current probability is 61 percent.) Statistically, Charleston is a relatively safe place. There is a less than 5 percent chance a

hurricane will hit the South Carolina coast, a less than 3 percent chance a hurricane will pass within forty miles, and only a 1 percent chance a Category 4 or Category 5 hurricane will strike.[26] The yearly statistical probabilities tend to obscure one important fact, however. The question is never "if" a major hurricane will strike, but "when."

By 1989, Charleston's 319-year history had been etched with the effects of great storms. The first major recorded hurricane, in August 1686, broke up a Spanish attack and was remembered fondly as "wonderfully horrid and distructive [sic]." In 1706, another storm with good timing scattered the ships of an attacking Spanish and French fleet. A violent storm in 1713 damaged ships in the harbor, flooded streets, swept away houses and drowned nearly seventy people. In 1752, a hurricane that might have been a Category 4 flattened buildings within a thirty-mile radius of Charleston as its ten-foot storm surge swept the quarantine house off Sullivan's Island with fifteen people inside and nearly covered the entire downtown Charleston area. The great gale of 1804 ravaged the second Fort Moultrie, washed away fifteen to twenty houses on Sullivan's Island and flooded downtown Charleston with chest-deep water. The storm of 1813 sent flood tides through the sally port at Fort Moultrie, covered the parade ground with water four feet deep and left nine people dead. The storm of 1825 did major damage, a hurricane in 1853 left an epidemic of malaria in its wake and a storm in 1873 destroyed the Southeastern Railroad depot. The Category 3 hurricane of 1885, one of the worst in Charleston's history with winds of 125 miles per hour, killed twenty-one people. In 1893, another Category 3 hurricane, nearly as strong as that of 1885, with 120-mile-per-hour winds, was accompanied by a storm surge that covered barrier islands up and down the coast. The 105-mile-per-hour winds of the August 27, 1911, hurricane hit on a Sunday when

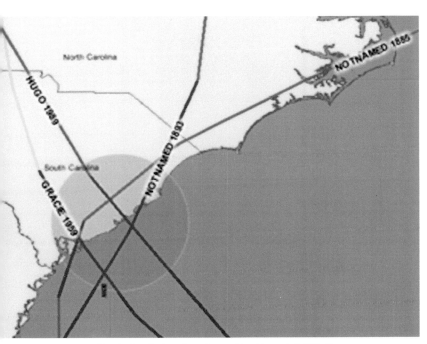

Major storm strikes in South Carolina. Storm Not Named (1885, Category 3), Storm Not Named (1893, Category 3), Gracie (1959, Category 4), Hugo (1989, Category 4). *Courtesy NOAA.*

Sullivan's Island was filled with some five hundred vacationers and destroyed more houses on the island than any previous storm. In Charleston, seventeen people were killed and property losses exceeded $1 million. Weakening Category 1 hurricanes came ashore in 1913 and in July 1959. In September 1959, Hurricane Gracie, a Category 4, hit the coast forty miles south of Charleston with sustained winds of 120 miles per hour and gusts up to 140 miles per hour.[27]

The 1911 storm had a long-term economic impact. Since the Civil War, freed African Americans wove sweetgrass baskets to

store wild herbs and food: "dried grain, okra, salted fish and corn." The hurricane destroyed the harvest. Desperate families taking sweetgrass baskets to Charleston "to sell for the next meal" not only found the income they needed, they created a new commercial enterprise. Soon, sweetgrass baskets were being shipped to New York.[28]

The most dangerous storms are the Cape Verde tropical cyclones. In late summer, the seasonal monsoons across the African savanna spawn clusters of thunderstorms that move westward into the African steppes. Driven by upper atmosphere steering currents, the storms leave the western coast of Africa to form tropical depressions in the waters just south of the Cape Verde Islands. With the warm Atlantic ahead of them and no cool water or land to dissipate their energy, the depressions can strengthen to tropical storms and then into powerful and long-lived hurricanes. As they approach the North American continent, Cape Verde storms typically follow one of three courses. Some continue to the west, crossing the Antilles into the Caribbean. Others track further north into the Gulf Coast of the United States or move through the Bahamas into Florida. In late summer, as the Bermuda High pressure ridge strengthens over the eastern Atlantic, steering currents curve storms passing north of the Antilles further northward. These take aim at the Carolinas.

Hurricane Hugo was a typical Cape Verde tropical cyclone. Its origins were detected on satellite imagery on September 9,1989, when a cluster of thunderstorms moved off the coast of Africa. Tropical depression number eight formed on September 10 southeast of the Cape Verde Islands, moved westward at more than twenty miles an hour and strengthened to become Tropical Storm Hugo on September 12. On September 13, now located about eleven hundred nautical miles east of the Leeward Islands, Hugo grew into a minimal hurricane. On September 15, a National

Oceanic and Atmospheric Administration (NOAA) Lockeed Orion turboprop named Miss Piggy made a low-altitude penetration into Hugo's eye. The crew was expecting winds in the range of 110 to 115 miles an hour. But as the plane penetrated the eye wall, it lost an engine and dropped to seven hundred feet above sea level before the pilots could regain control. Instruments recorded the extremely low barometric pressure of 918 millibars and measured sustained wind speeds a fraction over 190 miles an hour. Hugo had grown into a Category 5 hurricane at what would later be determined as its maximum intensity, ground level wind speeds estimated to be slightly over 161 miles per hour. For two hours the NOAA aircraft was forced to circle inside the eye before finding a break, and it was so battered that it was forced to dump fifty thousand pounds of fuel before it could return to base, substantially damaged. The official summary of this mission reads, "Energetics [inner plane] on Hurricane Hugo. The flight took off from Barbados at 1613Z on 09/15/1989 and landed at Barbados at 2021Z with 1 penetration. But, boy, was it a Doozy!"[29]

Over the next two days Hugo shifted toward the west-northwest and slowed. On September 17, another NOAA aircraft reported winds over 155 miles per hour just as the hurricane slammed into the islands of Guadeloupe and Montserrat near midnight. Turning to the northwest, Hugo passed over St. Croix with maximum surface winds estimated at almost 140 miles per hour, damaging or destroying 90 percent of all structures on the island. Accelerating and turning northward, Hugo struck the eastern tip of Puerto Rico at noon on September 18 with sustained winds ranging from an estimated 126.7 miles an hour to a measured 103.6 miles per hour. After leaving over thirty thousand people homeless, Hurricane Hugo passed out of the Caribbean.

By the 1980s, the National Hurricane Center forecasts had become extremely trustworthy. The accuracy of the seventy-two-

hour predictions of a storm's path, updated every four hours, had improved to within 394 statute miles. With a seventy-two-hour error of only 177 miles, the forecasts of Hugo's expected storm track would be even more accurate.

The combination forecasts of a hurricane's track, intensity and speed were far from perfect, however. Weakened by the mountainous terrain of Puerto Rico, Hugo emerged into the Atlantic Ocean on September 19. Moving north-northwest at almost fourteen miles an hour and with winds down to slightly over 103 miles per hour, on September 20 Hugo was reclassified downward to a Category 2 hurricane that appeared to be taking aim at the Georgia coast. Warned that it could be the landfall target, the city of Savannah evacuated.

But driven by the clockwise winds of a Bermuda High off the east coast and the counterclockwise winds of a tropical low front moving across Georgia, Hugo turned more northerly, stayed off the Georgia shore and tracked toward the Carolinas. At 6:00 a.m. on September 21, in public advisories that said that "little significant change in strength is likely," the National Weather Service issued a hurricane warning for the entire South Carolina coast and low-lying areas. By midday, as Hugo was building strength and picking up speed, an estimated 250,000 people were evacuating. Their precautions would prove wise. In the thirty hours immediately preceding landfall, Hugo grew from a Category 2 hurricane to a Category 4 and its forward speed increased so rapidly that the National Hurricane Center lead time in issuing warnings dropped from Puerto Rico's forty-two hours to eighteen hours for South Carolina.[30]

On the night of September 21–22, moving at 25 miles per hour and accompanied by storm surges ranging from five to twenty feet above mean sea level, Hugo hit almost perpendicular to the South Carolina coast. High-level winds were a measured 161 miles per

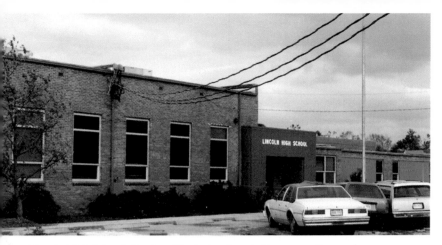

Lincoln High School. *Courtesy Charleston County Emergency Preparedness Division.*

hour at twelve thousand feet just before landfall and ground level sustained winds were estimated at 138 miles per hour, with higher-level gusts. Hurricane-force winds radiated out 140 miles from Hugo's eye, and tropical storm winds 250 miles out. Once ashore, Hugo's northeastern quadrant, the strongest part of the storm, roared into the Frances Marion National Forest, shearing off tens of thousands of trees at a height of fifteen to twenty feet above the ground and destroying enough timber to "run an inch-thick, foot-wide board around the earth seven times" or, as South Carolina Governor Carol Campbell Jr. would later say, to build houses for the entire population of West Virginia. The dangerous storm surge poured water five feet deep over the parade ground at Fort Sumter in Charleston harbor and flooded into downtown Charleston. Farther north, the small fishing communities of Awendaw and McClellanville, more than three miles from the ocean, were submerged. Many of McClellanville's 1,125 people had taken shelter in Lincoln High School, a designated shelter thought to be safe at sixteen feet above sea level. But there the

tidal surge was twenty feet above normal, and as the waters rose in darkness people climbed for their lives and parents stood in neck-deep water to lift screaming children into the roof rafters.[31]

On the weak side of Hurricane Hugo's eye, the Charleston peninsula experienced Hugo as a Category 2 storm, but the destruction was nevertheless intense. More than four thousand of Charleston's historic structures suffered some type of damage. More than 80 percent of the homes on Folly Beach on the south side of Charleston Harbor and beachfront homes up and down the coast were destroyed. Boats torn loose from their moorings were everywhere piled in heaps by the storm surge, among them yachts totaling more than $50 million that had broken free from the Isle of Palms marina and come to rest on Goat Island. Hugo roared into Berkeley County with recorded wind gusts up to 120 miles per hour eighty miles inland, destroying some twelve hundred mobile homes, scattering vehicles, felling trees and killing eight people.

The hurricane followed evacuees who sought shelter in Columbia straight up the I-26 corridor to batter the South Carolina capitol. A ship moored in the Sampit River measured sustained winds of 120 miles per hour. Shaw Air Force Base recorded wind gusts at 110 miles per hour. Bending to the north, Hugo's 69-mile-per-hour sustained winds and 99-mile-per-hour gusts shattered the glass in Charlotte's downtown skyscrapers and left extensive damage in the major metropolitan area. Hugo drenched Virginia with torrential rains that flooded roads and cut power to two million people. By the time Hugo finally crossed the Canadian border, it had claimed five lives in Puerto Rico and the U.S. Virgin Islands, twenty-four more elsewhere in the Caribbean and twenty-one in the mainland United States. Ultimately, the number of deaths associated with Hugo would reach eighty-two.[32]

Aerial view of downtown Charleston. *Courtesy Charleston County Emergency Preparedness Division*.

Vanished beachfront house. *Courtesy Charleston County Emergency Preparedness Division*.

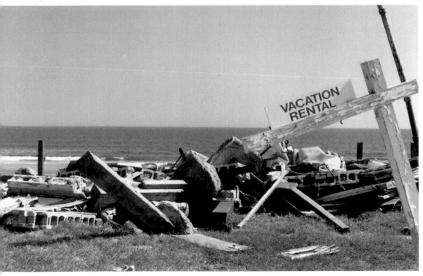

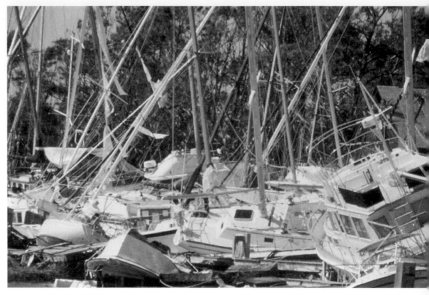

Boats piled up at the Isle of Palms Marina. *Courtesy Charleston County Emergency Preparedness Division.*

Hugo was the tenth most intense hurricane to strike the United States between 1851 and 2005. Along the entire eastern seaboard of the United States, no previous tropical cyclone had recorded a lower barometric pressure, stronger winds or higher tidal surges at landfall. At the time, Hugo was the second costliest tropical cyclone, with property loss and damage estimated at $7 billion in the United States and $3 billion in the Caribbean. Insured losses would total $4.2 billion. A week after South Carolina's worst twentieth-century hurricane, fifty-six thousand people were still homeless in the Carolinas. As late as 1999, many were still rebuilding.[33]

The Storm

The Village Still Sits by Jeremy Creek
(McClellanville, SC) Excerpt

The broken rail on Tom's dock
still not mended;
the six-foot high mudstains
half way up the walls
of Miss Aggie's parlor,
the untilled fields
of Heath's farm,
piles of dead trees
along the roadside.
All speak of the unspeakable.

Last year's giant storm
when winds howled like a plat-eye hag
and tidal surge
lifted forty-foot shrimp boats
up and over houses,
leaving them on their sides
like a string of fish
at Miss Em's back door.

Giant oaks, once hung with Spanish moss,
were draped for weeks
with wind-torn clothes,
picture frames,
refrigerator doors
and the steps to someone's
home.

Irene Nuite Lofton

III.
THE MARTIAL LAW TIME

Curfew at Dark

*Our island has been amputated from
the mainland;
its linking bridge
cocked like a broken elbow
against the sky.*

*Camouflaged soldiers
ride up and down our island
in armored trucks;
their guns at the ready.*

*Curfew is called at dark.
Our lanterns shine out
against the night,
as we try to find home
again.*

Irene Nuite Lofton

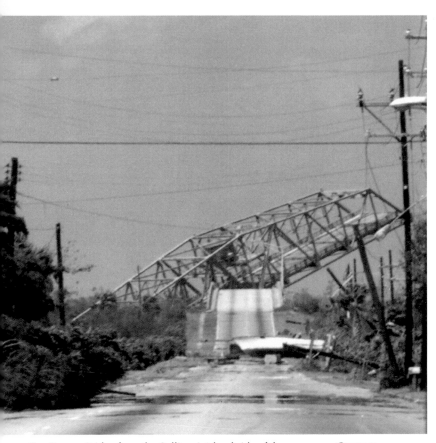

Ben Sawyer Bridge from the Sullivan's Island side of the causeway. *Courtesy Sullivan's Island Fire Department.*

When Hurricane Hugo dumped the Ben Sawyer drawbridge into the inland waterway, residents of the Isle of Palms and Sullivan's Island immediately became members of communities whose experience separated them from everyone else. One separation was the geographical divide between residents of the barrier

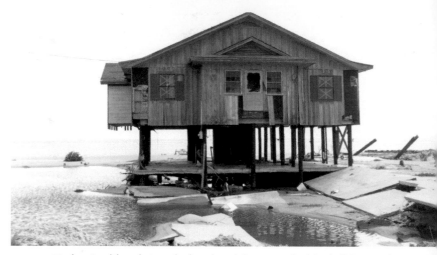

Undermined foundation of a front beach house on the Marshall Reservation. *Courtesy of authors' personal collection.*

islands and people on the mainland who were able to immediately salvage belongings, camp out, tend to damaged houses and perhaps take advantage of the intervals between hard rains to make repairs to protect their property against further harm. With the bridge down, and prohibited by emergency decrees from returning to their homes, islanders could do none of these things. A second separation was the political fracture that quickly opened between township officials on the barrier islands who made the decisions to bar access and residents who demanded to be allowed to go home.

THE AUTHORITIES

There are two major components to disaster planning: the predisaster phase and the aftermath. Much of the pre-Hugo planning had been thorough and comprehensive. In 1989, Charleston County's 950 square miles were mostly rural, with the popula-

tion of more than three hundred thousand living predominately in the metropolitan areas and on the built-up barrier islands. A hurricane evacuation study completed in 1986, three years before Hugo, had pointed out the dangers of Category 2 and higher hurricanes, particularly from coastal flooding. New hurricane evacuation plans had been drawn up immediately and thereafter were tested in annual exercises. The Town of Sullivan's Island, Charleston County, and the State of South Carolina all had up-to-date plans to move the large coastal population out of harm's way quickly.[34]

Governments at all levels stood ready to act when an emergency threatened. The South Carolina Code of Laws gave the governor the authority to direct and compel the evacuation of all or part of the populace from any stricken or threatened area, control people's movements in the emergency area, call the National Guard into state service to respond to local requests for assistance and, when the magnitude of an emergency is beyond the ability of local governments to respond, to take over their functions. In 1987 Charleston County had established an Emergency Council as part of its emergency operations plan to coordinate government resources in major emergencies. Sullivan's Island ordinances gave the mayor the "duty" to declare a state of emergency under certain conditions, after which the mayor had the considerable authority to request the assistance of the military and police forces, declare curfew and impose "such conditions as to him shall appear necessary to protect life and property and maintain peace and good order." The Isle of Palms ordinance was similar. Hurricane planning on Sullivan's Island concentrated on making sure people were aware of the danger and monitoring their evacuation.

The aftermath phase of the planning established the Charleston County Disaster Preparedness Agency as the coordinating authority for the help that would be coming from the state and federal governments. From that body, Sullivan's Island would request the assis-

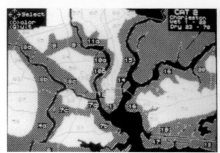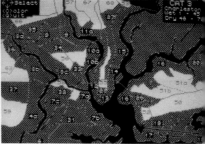

Charleston County storm surge maps. *Courtesy Charleston County Emergency Preparedness Division.*

tance it needed. In early September 1989, well before Hurricane Hugo formed, these plans were reviewed and briefly discussed at a meeting of the Sullivan's Island Town Council. All departments reported that they were prepared.[35]

> *I raised my hand and asked a question. "What will be the duties of Town Council in an emergency." I was told that as emergency decrees would be in force, there would be no duties. So when the storm came, I evacuated with a clear conscience.*

Councilman (now Mayor) Carl Smith

Immediately after the notification of Hugo's potential threat by the National Weather Service, Lowcountry officials took the steps called for in the plans. Preparations began on Sunday, September 17. By Wednesday, September 20, South Carolina was under a hurricane watch and forewarned motorists were crowding into service stations. Linda Lombard, former County Council chair (and current Charleston County magistrate), remembers,

> *I had been elected chair in January. County Council was a part-time job. I was trying a case in Family Court on Wednesday*

when I got word that Charleston was going to take a direct hit. I approached the bench and the judge, bless her heart, continued the case until further notice. Then she asked, "How bad is it?"

"It's going to be bad," I said. "We're going to announce an evacuation at six o'clock. Get your children and leave right away."

Our emergency plan included a list supplied by the school board of schools on high ground that the board would make available as evacuation shelters. The Red Cross would staff them. Principals all over the county were contacted to get the keys to the buildings and we had the first shelters open at midnight.

On Thursday, September 21, Governor Campbell declared a state of emergency, ordered a mandatory evacuation of the beachfront, low-lying areas and mobile homes and put the South Carolina National Guard on standby alert. Activated engineering and military police units of the Guard began moving to their pre-positions in anticipation of the coast sustaining heavy damage.[36]

Charleston County Administrator (currently a member of Charleston County Council) Ed Fava began to think about what could be done in advance of the storm's arrival to plan for the aftermath. Calling on his previous experience as a naval officer for twenty-six years, he began to improvise.

We had no book on what to do when the hurricane comes. I put together a group of thirty to forty county people with various skills: automobile mechanics, building inspection staff who knew about buildings and structures, people from the county works department, key financial people, electricians, carpenters, etc. I told them we would stay together in the Charleston County Emergency Operations Center during the storm. I ordered all vehicles filled with gas and all refueling sites to be topped off. I ordered our EMS

*vehicles and police cars to be stored as safely as possible. I asked
everyone to think about what would be needed. Then I asked them
to go home and take care of their families, and then come back.
When we went to the command post we took important files with
us and also cash in case we had to buy things.*

By dawn on September 21, increasingly heavy evacuation
traffic was heading inland along I-26, the main route inland from
Charleston. By 8:00 a.m., it began to slow and a jam developed.
Worried officials were examining the possibility of closing the
inbound lanes to Charleston and reversing them when, as quickly
as it had formed, the jam cleared itself.[37]

SULLIVAN'S ISLAND AND THE BEN SAWYER BRIDGE

On the morning of September 21, the Sullivan's Island town hall
was converted into the command center. Fire Chief Anthony
Stith, the town's three paid firemen and members of the Sullivan's
Island volunteer fire and rescue team began safeguarding their
equipment. The air raid siren started up early in the morning.
Chief Jack Lilienthal stationed his four-officer police force to
oversee the evacuation traffic from the Isle of Palms crossing over
the Breach Inlet Bridge and the heavier traffic exiting both islands
at the Ben Sawyer Bridge. "I think you should stay on the island,"
Lilienthal told Dr. George Durst Jr., that morning. "I think we
will need a medical presence." Durst, Lilienthal knew, had
commanded a medical detachment in southeast Asia during the
Vietnam War, and was not unacquainted with operating under
less than optimum conditions.

During the afternoon, as weather conditions began to deterio-
rate and evacuation traffic began to thin, officers checked homes

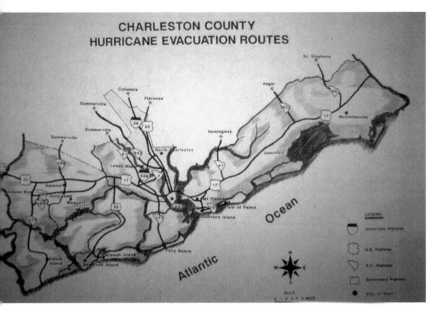

Evacuation routes. *Courtesy Charleston County Emergency Preparedness Division.*

to encourage those who had not left to do so immediately. "We then went through the streets and used the loudspeakers to say: 'Mandatory Evacuation, leave immediately,'" Sergeant David J. Price remembered. "I must have said that a million times. There were several senior citizens I knew that could not get off the island by themselves, so I went and helped them move to the Moultrie Middle School shelter. I was really concerned about getting them to safety."[38] For most island residents, the encouragement to leave was all they needed. Others balked. A group that had stayed in a beachfront home and purchased provisions so they could see what a hurricane could do and some surfers who had settled in at the ocean to enjoy the high waves made reluctant exits.[39]

Father Lawrence B. McInerny remembers,

> *I had a house on the island, on the same lot as my two aunts, one born in 1900 and the other in 1904 and my uncle, who was born in 1907. [Police Lieutenant] Danny Howard came down the street and told me I had to leave. I was trying to convince him to let me stay and thought I was making headway when I pointed to the house and said, "Besides, I can't go, I have my two aunts in there and they won't leave."*
>
> *"Those two old ladies are still here?" Howard said. "No way; they have to get off the island."*
>
> *"I've tried," I answered, "you want to see what you can do?"*
>
> *Howard went into my aunts' house and began to explain, at first gently, telling them how bad the incoming storm was, and then with more insistence.*
>
> *"We'll see," said my eighty-nine-year old aunt patiently.*
>
> *"There isn't going to be any 'we'll see,'" Danny answered. "If you aren't off the island by 4:00 o'clock, we will evacuate you to a shelter."*
>
> *They really didn't think it was necessary to go. They had lived on Sullivan's Island all their lives. They hadn't ever evacuated; in fact, in the early years, when there was no warning of a storm, it wasn't even possible. We all left. When I was able to bring them back to the island much later, my aunt born in 1904 said that Hugo had been worse than the hurricane of 1911.*

Twice more that afternoon Lilienthal would contact Durst, the last time telling him that the storm appeared to be much worse than they had initially thought, and that he, too, should leave the

island. "The causeway was deserted and lonely when I crossed late in the afternoon," Durst remembers.

The 240-foot long 500-ton swing span of the Ben Sawyer Bridge sits on an 18- to-20 inch bronze bearing on the center support pier. The bridge can swing freely in each direction, but opens clockwise because the mechanism is set that way. At each end of the bridge, on the underside, there is a hollow support pier with two wedges. When the bridge swings to close, the wedges are driven into wedge shoes that raise the bridge slightly and lock it down. Two wedges on the center pier lock the same way. In its closed position, the weight of the bridge is transferred from the wedges on the end piers to the wedge shoes through the piers and down the foundation to the ground. In its locked configuration, the bridge cannot move. Prior to Hugo's arrival, but after the evacuation from the barrier islands was complete, Department of Transportation crews took the extra precaution of adding tie-downs. Using a come-along, they wrapped steel cables around the guardrails on both sides of the bridge and attached them to the guardrails where the bridge meets the roadway in the form of an X.

The Sullivan's Island town hall had been selected as the disaster command post because the building was brick and thought to be a safe seventeen feet above mean sea level. But radio reports of hurricane winds up to 135 miles per hour and a twenty-one-foot storm surge approaching the islands suggested extremely dangerous conditions, and at the last minute Police Chief Lilienthal and Fire Chief Stith made the decision to get out. Fireman (now Building Official) Randy Robinson led the caravan driving a fire truck, its flashing lights a beacon to those following behind.

The bridge was shaking and bouncing when Robinson began to cross and he had to swerve to avoid the concrete posts and bridge railing in the roadway. The steel tie-down cables had held but the

guardrail posts had been pulled out of their foundations. Unable to see anything but the driving rain white in his lights straight in front of him, he thought, "If I go into the water, everyone behind me is going in too."

The shaking continued as the Sullivan's Island and Isle of Palms contingents raced over the bridge. It was pitching even more wildly when Chief Lilienthal, the last car in the line, approached. "Punch it," an officer radioed, "the bridge looks awfully shaky." Lilienthal was still on the Ben Sawyer Bridge when it began moving even more violently and began swinging back and forth. He later recalled that seconds after his car touched the causeway he looked back and saw that the bridge had plunged into the water.[40]

But Lilienthal was not the last to leave the island. Police Lieutenant (now Police Chief) Danny Howard had stopped to pick up a generator and some tools he thought would be needed, and he and a water department employee made the last crossing. "The bridge was moving violently when I was going over," Howard remembers, and "the water on the Mt. Pleasant causeway was already several inches deep. I don't know if that was rain or the beginning of the tidal surge."

For the Ben Sawyer Bridge to move out of its closed position, it must swing about eight inches so the wedges can clear the wedge shoes. And once free of the wedge shoes, it can continue to pivot.[41] The bridge was moving before the first vehicle had crossed with enough force for the tie-downs to break concrete posts. The bridge also had to be out of alignment, but Robinson was unable to see that: "I did not know where I was or if I was off the bridge," he says, "until I glanced to my left and saw the buildings at Toler's Cove."[42]

It is impossible to know exactly what happened, but there are two scenarios. Given the location of the concrete posts in the roadway, the bridge had turned counterclockwise, and at least once had

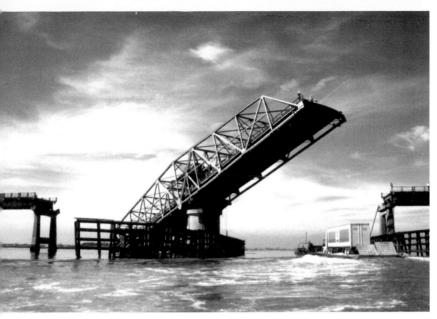

Ben Sawyer Bridge after Hurricane Hugo. *Courtesy Emergency Management Division, Charleston District, Army Corps of Engineers.*

swung so far open and was bouncing so violently that Lilienthal was convinced he had seen it go into the water. For Howard to cross afterward, either the hurricane force winds that were striking along the entire span shifted enough to push it back in place or the bridge kept turning and made a complete circle. Neither scenario is implausible, for the next morning the Ben Sawyer Bridge was in the water with its Sullivan's Island end facing Mt. Pleasant and vice versa. The only thing we know for certain is that after Howard crossed the bridge swung a considerable distance before tilting and beginning its slide into the water. Only the fact that the saddle portion of the pivot mechanism embedded itself in the pier cap stopped the span before it came to a precarious rest on the outside edge of its center support pier.[43]

The Sullivan's Island firemen waited out the storm at the home of Chief Stith. The police headed to the home of an officer who lived near the Mt. Pleasant Command Post on ground high enough to be safe from flooding. Exhausted from a day that was beginning to approach twenty hours, they wanted to rest and to be able to get back to the island after the storm passed. But no one could really sleep. After waiting out the first half of the hurricane, they emerged into the quiet of the eye.

For the first time, the feeling began to sink in that this might not be just another storm.

THE LOWCOUNTRY

The Thursday–Friday night of September 21–22 was a harrowing experience everywhere. Electric power disappeared and people huddled in the darkness. West of the Ashley River, a Citadel professor and his wife sat frozen at the opposite ends of their living room couch as one pine tree after another crashed through the roof, the last one landing between them. Downtown, when the howling wind reached its greatest intensity, a College of Charleston professor sought safety in the strongest room in her house by climbing into her bathtub. At the Charleston County Emergency Operations Center on Leeds Avenue, people listened to reports of beds being sucked out of the fifth floor of a hospital located twenty-five miles inland. They continued to take telephone calls and give advice as a radio tower and trees fell on the metal roof and it began to fail. "A newly hired EMS deputy was next to me talking on the telephone when the debris began to rain down," County Council Chair Linda Lombard remembers, "and we both dove under a table. He still had the phone and was talking to a little girl, helping her deliver her mama's baby." With ears popping and the howling wind driving the rain into the building,

the group waited until the eye of the hurricane was directly overhead; then, in the brief calm, everyone gathered what they could and equipped with flashlights scrambled over downed trees and power lines to the smaller brick and concrete block Public Works Administration building some 350 yards away. There they sat, trying to protect themselves as they felt the building shake, listening to the squawk of radios and worrying about the safety of their families.[44]

As dawn broke, throughout the Lowcountry public officials began taking extraordinary steps to address the emergency. Charleston Mayor Joseph P. Riley Jr. announced a sunrise to sunset curfew to be enforced by police assisted by National Guard armed with M-16 assault rifles with fixed bayonets. Police Chief Ruben Greenberg told police to beat, not arrest, looters because there was no more room in the jails or anywhere else to keep them.[45]

"Our first task was to get emergency vehicles out to see what conditions were, to make an assessment," County Administrator Fava remembers. County Council Chair Linda Lombard remembers,

> *King Street was eerie. Nearly all the buildings had suffered serious roof damage, but looking at the facades from ground level they appeared undamaged. The county courthouse and the office building were so badly damaged we condemned them on the spot. We tried to get to outlying areas—John's Island, Hollywood—but the roads were impassable. The previous year we had tried very hard to get an ordinance enacted to protect our historic trees. I had gone to the state legislature several times. After the first helicopter reconnaissance I was told, "We don't need the ordinance now. Our trees are gone."*

To deal with the conditions that now faced them, the Lowcountry needed substantial emergency assistance, but it would be several days before much of anything would become available. The devastation was so widespread that state officials were struggling. The damage was so extensive that it hampered the dispatch of police from upstate counties to the Lowcountry and the deployment of the National Guard. Police, fire and rescue units around the state operated on different radio frequencies, making it difficult to coordinate relief efforts. Relief supplies stacked up in some locations while others went begging. The emergency broadcast system failed to work. Recovery and volunteer personnel were hampered by not knowing where to begin or what they would have to work with. Recovery efforts were also initially impeded by the confusion arising from the on-scene presence of National Guard, Regular Army and Marine Corps units, each responding to a different chain of command and each having individual missions and priorities. Compounding this problem, county and municipal employees, guard personnel and members of the regular military forces were unclear on their relationships with each other and their prescribed relationships with the South Carolina Emergency Preparedness and Law Enforcement Divisions, the Federal Emergency Management Agency (FEMA), the U.S. Army Corps of Engineers and other entities involved in disaster relief.[46]

That said, with improvisation and ingenuity, things got done fast. A battalion of some five hundred Marine Corps engineers from Camp LeJeune and Cherry Point, North Carolina, arrived and announced that they were field troops and should be sent where conditions were worst. County Administrator Fava said McClellanville had been so hard hit that no one knew exactly what the conditions were, but they needed everything. The Marines needed only the answer to one question: "Where is McClellanville

on the map?" An official from Manning called the Emergency Center and told County Council Chair Lombard, "We have been hit badly, but no one knows. We need supplies." The Salvation Army had supplies but no trucks, Lombard discovered, so she called an auction company in Charlotte that she represented and asked if they could get an eighteen-wheeler through to Charleston. The next morning two drivers walked in with instructions "to find Linda." The relief supplies were in Manning that afternoon.

Recalls Mayor Riley,

> *Everything was simultaneous. A hurricane is not like other natural disasters because it cuts such a wide swath of destruction. Our priority was to do everything we could to get people's lives back to normal as quickly as possible in order to lessen the psychological impact. If someone said it would take five days to get something done, we said do it in a day and a half. It was important for people to see progress. If you are living in a badly damaged house and then electric power is restored, it's not a return to normal but you think, well, things are getting better.*

Dealing with FEMA turned out to be everyone's most difficult bureaucratic problem. Mayor Riley got an early indication of the agency's priorities when, as Hugo's eye passed directly over the command station for Charleston's city government, he asked the FEMA official present what advice he had to give him at this time. The response: "Be sure to account for all your expenses." Later, with electric power out in Charleston and beyond and needing generators immediately for crucial facilities, the frustrated mayor found himself dealing with remote FEMA bureaucrats primarily concerned with documenting all expenses and paperwork before they would approve shipments.[47]

"One day some officials from Mississippi walked in," County Council Chair Lombard recalls. They said, "We went through Camille and came to help you deal with FEMA." That was a good thing, says Lombard. "FEMA has many regulations and you have to know your way through the maze. For example, we could get reimbursed if we rented generators or heavy equipment but not if we bought them because FEMA did not fund capital improvements." County Administrator Fava would later game that system by renting heavy equipment, getting the reimbursement and then buying it for the county at a reduced price.[48]

The County's biggest initial problem was persuading FEMA to provide enough Disaster Assistance Centers (DACs), says Council Chair Lombard:

> *DACS are critical because they are the only place where people who have lost everything can apply for help. FEMA had authorized only two DACS for a county that stretches more than seventy miles along the coast, and that was not nearly enough. It took the combined and repeated efforts of Senators Strom Thurmond and Fritz Hollings and Representative Arthur Ravenel to get a commitment for five or six DACS. But that was only a commitment. Before FEMA would come in, we had to find air-conditioned buildings of the right size to hold a specific number of desks and get them ready. Then, once the DACS opened, FEMA wanted to notify people by mail. We tried to explain that not only were mailboxes gone but so were entire houses. Later we had another problem. In the rural areas, people would not go to the DACS because they didn't want to take welfare. Some had lost everything but they still wouldn't go. I put a road show together and went to Mt. Pleasant, Anderson and a number of other rural areas to meet with groups in*

churches and elsewhere to persuade them that FEMA funds were their tax dollars at work and not welfare. We even used school busses to take people to the DACS.

South Carolina Senator Fritz Hollings would later summarize the federal agency as a political dumping ground, a turkey farm and the only agency he knew able to "mess up a two-car parade."[49]

SULLIVAN'S ISLAND: THE DAY AFTER

In the early morning hours, as Hugo moved inland, the Sullivan's Island police drove down the Ben Sawyer causeway, led by a highway department employee driving a road scraper to clear the debris. It was still dark at 6:00 a.m., but in the dim light they could see the bridge was down. Chief Stith borrowed a neighbor's boat for the fire department's return trip. The police were able to link up with a private boat shuttling back and forth.

Once on the island, police and firemen went to work to survey the damage and check on people who had stayed during the storm. They didn't have much to work with. A storm surge that did not quite reach the tops of the office desks had poured through the town hall, destroying records and scattering equipment.

It took time, but they eventually got the fire truck that had been left behind started and began to roll up Middle Street. At Station 22, Lilienthal and Stith found Durst's medical offices intact and set about making it their temporary command post. To gain entry, the back door was opened with a fire ax.

They continued up the island. A searching policeman found one man who had climbed on top of his kitchen table to escape the rising waters. He was ready to leave. Everywhere, there were downed and potentially dangerous power lines. Roads were covered with nails,

glass and debris. The storm surge, which had ranged between thirteen and a half to fifteen feet above mean sea level at Sullivan's Island, had floated houses off their foundations and some into the street. Lying about were scattered propane and even some illegal butane gas tanks, possibly leaking, perhaps ready to explode. At the far end of the island, they discovered the undermined Breach Inlet Bridge. Lilienthal later described the destruction as "like Vietnam but without the smell of death."

The few people who had stayed behind were examining their damage. The cousin of a local poet had brought in lumber before the storm so he could make repairs. He heard a crash in the middle of the night and opened the back door to see what had happened. There was nothing there. The back of his house had disappeared. He started to work.

Mayor Melvin Anderegg spent Friday unsuccessfully trying to get through to the Charleston County Disaster Center in an attempt to find authority, or someone in authority, to declare martial law. "I had attended the meeting at the Charleston Emergency Management Joint Operation Center the day before the storm," he later recalled, "and that's what people kept saying—martial law."

By Saturday, September 23, after an informal meeting with his police and fire chiefs, the town attorney and other officials, Anderegg decided that conditions on the island were too dangerous for residents to return. But some were already heading back, and by the afternoon so many boats had landed that Lilienthal finally ordered that no one except emergency crews would be allowed on the island until it could be made secure from looters. Soon he was threatening to arrest anyone, including homeowners, who was not on official business. The decree prohibiting residents from returning to Sullivan's Island was issued, informally and under the emergency powers provided the mayor in the town ordinances. By chance, it came at almost the same time that the first National Guard troops

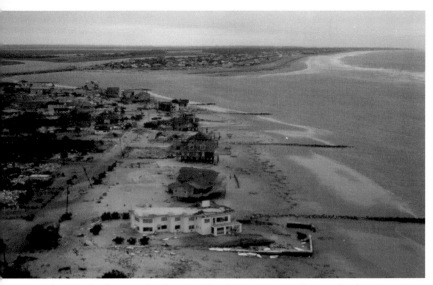

Aerial view of Sullivan's Island at Breach Inlet. *Courtesy Sullivan's Island Fire Department.*

The undermined approach to the Breach Inlet Bridge. *Courtesy Sullivan's Island Police Department.*

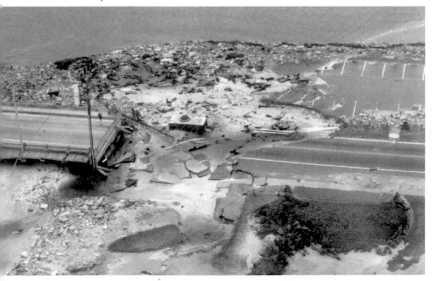

arrived on Sullivan's Island, ferried by a helicopter from an Air National Guard Medical Detachment.[50]

The arrival of the National Guard troops was a mixed blessing. Unsupplied and with poor logistical support, the soldiers relied on the town, and Sullivan's Island authorities found themselves stretching their meager resources to provide for them. Police, themselves foraging because food supplies had not been stocked, struck gold when a restaurant owner with a watertight walk-in cooler full of fresh meat offered the contents.

Despite terrible conditions, within two days, the major problems of downed power lines and scattered propane tanks had been neutralized on Sullivan's Island.

THE DECREES

Residents of both barrier islands knew little of what was taking place. The first post-storm reports they heard were that everything on the islands had been destroyed. Then came the news that there had been great damage, but battered houses still stood. Short of clothing, baby supplies, medicines and more, and not knowing what had happened to their homes, people wanted desperately to get back. But they were prevented from doing so.

Once Governor Campbell declared a state of emergency, various jurisdictions throughout South Carolina were free to enact their own regulations as they sought to restore order and safety. As on Sullivan's Island, Isle of Palms Mayor Carman Bunch issued an order effectively closing the island to all except emergency personnel.

Newspapers and the broadcast media picked up on the emergency decrees. Stories reported that Sullivan's Island and the Isle of Palms were placed under martial law after Hugo reduced much of the islands to shambles, that "hundreds of National Guardsmen

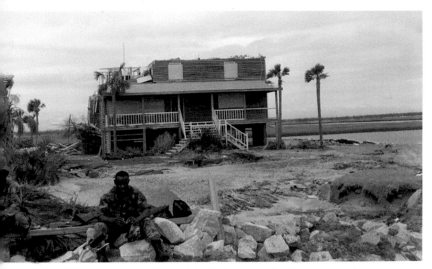

National Guardsmen on Sullivan's Island. *Courtesy of authors' personal collection.*

were on the islands to protect against looting," that "Guardsmen armed with automatic shotguns were keeping people off." For days, the drumbeat of martial law stories (occasionally misspelled marshall law) continued,[51] and incidents of homeowners being removed at gunpoint from the barrier islands by law enforcement officials made headlines.[52] The facts were quite different. The National Guard had dispatched an under-strength company of 111 Guardsmen to the Isle of Palms and a single squad (8 to 16 men) to Sullivan's Island, numbers that were a far cry from the "hundreds" being reported. The Guards were on the islands to assist the local authorities in enforcing emergency decrees, but they too referred to military authority for their actions. "I had come back to the island by boat and was up on my house repairing my roof," remembers Andy Benke, who became Sullivan's Island's town administrator in 2003, "when a National Guard soldier in uniform told me that the island was under martial law and I had to leave."

THE ISLE OF PALMS

After leaving the islands, Isle of Palms Police Captain James Arnold (now of the Georgetown, South Carolina, police department) and his officers had first gone to the evacuation shelter in Mt. Pleasant. It was so crowded that people were standing shoulder to shoulder, their arms flat against their sides. "Let's try my place," Arnold said. He lived nearby, but they couldn't get there because of the downed trees and finally threaded their way through the debris to another officer's house.[53]

On the Isle of Palms, conditions were chaotic. Helicopter patrols by the South Carolina Law Enforcement Division (SLED) and the National Guard estimated that fully one-third of the homes were totally destroyed and the remaining two-thirds badly damaged. Emergency personnel encountered snakes, surfacing propane tanks and the fifteen people who had avoided mandatory evacuation and now showed up at emergency tents asking for help. Volunteers and officials began the cleanup and set about the task of saving and securing family treasures. So many valuables, including rare coin collections, were found that South Carolina National Bank brought a vault to the island to help with security.

Isle of Palms residents divided about equally on Mayor Bunch's decision to bar access to the island. Half saw the decree as a necessity in stopping looters and keeping citizens safe. The other half, furious at not being allowed to return to check on their property, objected. Tattered nerves now gave way to dangerously tense confrontations as angry homeowners attempted to reach their property by boat without attracting the attention of weapons-bearing Guardsmen. People were turned back or evicted if they made it, and Guardsmen fired shots into the air to prevent homeowners or would-be looters from coming ashore.

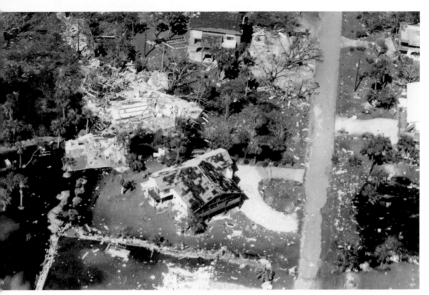

Damaged homes on the Isle of Palms. *Courtesy Charleston County Emergency Preparedness Division.*

Many islanders protested. On Saturday night, September 23, some two hundred Isle of Palms residents met in Mt. Pleasant. They expected Mayor Bunch to come and explain the "martial law" that had been declared at her request, and to ask to be allowed to return to their homes. As time dragged and the mayor did not make an appearance, they began to vent their frustrations in increasingly angry tones.[54]

An angry few directly challenged the authorities and the legitimacy of the emergency decrees. Charleston County Magistrate Jeanette Harper remembers one case clearly. It did not come to trial until some months later because the case was to be held on the island with an Isle of Palms jury. She presided as a municipal judge. To test Mayor Bunch's authority, and also to draw public attention to the emergency decrees, an Isle of Palms resident had

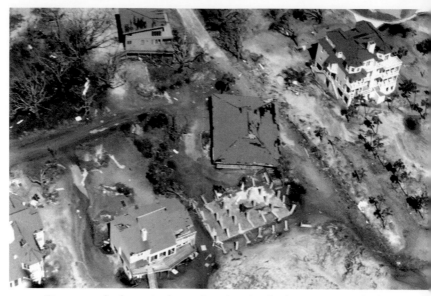

Damage and a house in the road on the Isle of Palms. *Courtesy Charleston County Emergency Preparedness Division.*

taken his boat to the island and attempted to dock. On board was a network television cameraman busy filming the event. The man refused police orders to stay off the island, landed and after a scuffle, was arrested. He asked for a jury trial. Both sides engaged highly regarded attorneys.

Feelings were still running high, and the tension in the room was almost palpable when Judge Harper convened the court. "I reasoned that with an Isle of Palms jury, not only would the island lose, everybody connected with the court would be in danger. I took note that an exit close to the bench stood ajar," she recalls.

The defendant testified that he had come to the Island in an effort to save what little remained of his home. Then the cross examination began. It went something like this:

Prosecutor: Did you have any lumber in your boat?
Defendant: No, sir.
Prosecutor: Did you have any shingles in your boat?
Defendant: No, sir.
Prosecutor: Did you have any nails?
Defendant: No, sir.
Prosecutor: Did you even have a hammer?
Defendant: No, sir.
Prosecutor: What did you have in your boat?
Defendant: Uh, a camera.
Prosecutor: Anything else?
Defendant: Someone to operate the video camera.
Prosecutor: So, you didn't come to the Island to work on your house, did you?

The trial was effectively over at this point, and the prosecutor polished off the defense in a concise summary that shifted sympathy from the defendant to island authorities.

THE SULLIVAN'S ISLAND TOWN MEETINGS

I will never evacuate again, but I will have ammunition.
Being held off the island at gunpoint was inhuman and a foolish action by people we elected. There were no dangerous snakes. I saw several National Guardsmen smoking, which made me wonder about the propane danger. In all, I feel martial law was a serious stressor for all residents. I hope the voters don't forget when the elections draw near.

Sullivan's Island residents

Island in the Storm

Mac Hammett, minister of the Sunrise Presbyterian Church on Sullivan's Island, had spent the day before the hurricane boarding up the church and parsonage and making sure that members of his congregation had someplace to go when they evacuated. The morning after the hurricane, he too returned to the island by boat to find his church completely destroyed. (Through December, services were held in the Presbyterian Church in Old Mt. Pleasant. By January, the congregation was back on Sullivan's Island, in a tent.)

After seeing the damage, like the municipal officials, Hammett also thought that the existing conditions, along with no working medical offices and no emergency evacuation facilities, made it too dangerous for people to return. But he also saw a problem that the overwhelmed personnel on the scene did not see: no one was paying any attention to the fact that concerned island residents needed to find out about their homes.

Preoccupied about how to take care of their duties, particularly to protect people from the dangers amid the destruction, none of the public officials involved in the brief, informal meetings on Sullivan's Island had time to give any thought to the residents, other than to bar them from returning for reasons of safety and security. When Hammett asked about holding a town meeting, he was told no one had time to make arrangements, but there was no objection to a meeting being called. On his own, he announced a town meeting for Sunday afternoon, September 24, in the Mt. Pleasant Presbyterian Church. He invited the mayor and town officials. The expectation was that a few people would show up and there would be some quiet discussion of conditions and problems.

Mayor Anderegg learned of the scheduled town meeting only hours before it began. He went with a small group, expecting to meet with a few residents to work out plans for dealing with the destruction. Instead, along with the surprised town meeting

conveners, he came face to face with more than two hundred Sullivan's Island residents and property owners.[55] At almost the same time that Mayor Bunch was announcing plans to ferry homeowners to the Isle of Palms, Anderegg and town officials found themselves trying to explain to an increasingly agitated crowd that because Sullivan's Island was virtually impassable and conditions too dangerous, there were no plans to allow anyone to return. The audience brushed his arguments aside and demanded to be allowed back to view the damage, salvage what they could and get clothes for themselves and their children. When town officials proposed forming a committee to videotape the damage and another committee to look into getting residents to their homes, the crowd jeered. Angry complaints were voiced, and when an elderly man marched down the aisle shaking his finger and said he had gone to the island and "been arrested by National Guardsmen carrying machine guns," the noise became deafening. Order was restored and the crowd mollified only by the promise that officials would provide answers at a second town meeting, to be held the next day.[56]

When he arrived in Greensboro, North Carolina, late at night, Councilman Carl Smith turned on a television set and learned that Sullivan's Island no longer existed. He had returned to attend the town meeting, and due to conditions caused by the storm got there just after the meeting had started. Afterward, he and the other town officials met informally.

Sunday, September 24.

From somewhere I learned there would be a town meeting at the Mt. Pleasant Presbyterian Church and we could get information. I arrived early. The church was already crowded. The mayor hardly spoke but other officials talked about glass

> *and nails and debris covering the roads and the countless other reasons why it was not safe to let anyone back on the island. Nearly everybody in the crowd had left with only a couple of suitcases. Several loudly demanded to know about their property and possessions and when they could get back to see what was left. The speakers had no answers, but they did promise there would be another meeting tomorrow.*

Chief Lilienthal accompanied the mayor to the second meeting, "to protect him from a lynch mob," he later said. At first, things went no better than before. There still were no plans for people to return to visit their homes. The audience heard new stories from residents about going to the island by boat and being turned back "by Guardsmen carrying loaded rifles." Suddenly, the rapidly brewing confrontation was defused by quick thinking. Many at the *ad hoc* town meeting were businessmen and professionals. Some had longtime family connections to Sullivan's Island; others had lived there for more than a decade. Several had been actively involved in local government at one time or another, but had neither the time nor any inclination to pursue local politics. What they had in common was a background in running things and long-standing personal contacts with town officials. Frustrated at watching what seemed to be the inability of the township government to connect with its citizens and certain that the immediate problem was to avert a clash between town officials determined to keep people off the island and angry residents equally determined to get back, they hurried to the front of the church. At their suggestion, the town meeting was briefly recessed. Behind closed doors, an agreement was quickly hammered out. Township officials would continue with their post-disaster responsibilities while *ad hoc* citizens committees working with township officials would recommend and oversee the

procedures that would allow residents to return to check their homes and properties. This was the news the audience wanted. They were also told that pictures taken on the island would be made available at the church later that night and boatlifts would begin as soon as possible. As the meeting ended and people filed out, Mt. Pleasant police appeared at the doors. They had been called by the worried Mt. Pleasant pastor concerned that an "angry mob" was about to destroy his church.[57]

Monday, September 25.

The church was so crowded that I could barely find a seat in the balcony. Officials mostly repeated what they said yesterday and quoted the governor as saying that because snakes were rampant on the island and almost all the homes had been totally destroyed, with debris everywhere and propane gas bottles floating all over, conditions made it too dangerous for people to be allowed back. People stood and began pointing out that conditions being described were just as bad on this side of the inland waterway but nobody was trying to keep anyone from returning to homes in Mt. Pleasant. Mothers pleaded to be allowed to get clothes for their children. Men spoke of trying to approach the island by boat and being shot at. No answers were forthcoming and the crowd was becoming visibly upset. Then some people hurried forward and the meeting recessed. When it reconvened, we were told that committees were being formed, that some pictures of homes would be made available at the church that night and plans were being made to get residents back to view the damage. This was good enough. As we left, I passed unsmiling, uniformed Mt. Pleasant police in the aisles and at every door. I thought to myself, "When did we become the enemy?"

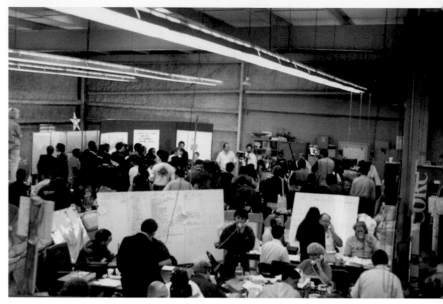

Charleston County disaster center. *Courtesy Charleston County Emergency Preparedness Division.*

Elsewhere, the emergency was generating the formation of other *ad hoc* connections. When George Durst returned to the island, he first went to his house, now on the ground on top of its collapsed foundations, and then to his family practice medical offices, which, to his relief, had escaped any serious damage. No sooner had he agreed with the decision to turn the building into a temporary town hall than he received a telephone call from island resident Charles Condon, the Charleston County Solicitor, whose wife, Dr. Emily Y. Condon, MD, was in practice with Durst. Referring to the Charleston County Disaster Center, through which the relief efforts were being coordinated, Condon said, "Sullivan's Island hasn't got anyone here. The Isle of Palms does, Mt. Pleasant does, everybody else. Somebody from the town needs to get up here." Durst relayed the message to Chief Lilienthal and volunteered. In the next weeks,

he was Sullivan's Island's seat at the table and through him the town's requests for assistance were relayed forward.

Ferrying operations to Sullivan's Island began Tuesday, September 26, with tight security to see that only islanders made the trip. People were allowed only a short time on the island to see their homes. For the elderly and those who were disabled, there was a helicopter flight.

Tuesday, September 26.

We were allowed to return to the island today and arrived at the public boat dock at Shem Creek at 7:00 a.m. carrying materials to make temporary repairs; two heavy rolls of plastic, water, drinks, tools, video and regular cameras, plastic bags, flashlights, batteries, and extra film. We waited in line until noon. Driver's licenses were collected. Only people with identification that tied them to Sullivan's Island were allowed on the boat. We were told we would be permitted to stay on the island for only two and a half hours. Everyone submitted to the herding, and after paying the requested $2.50 per person contribution for gas, began boarding the Carolina Clipper, normally a Gulf Stream fishing vessel, at about 12:30 for the trip to the National Park Service dock at Ft. Moultrie. On the way, we passed a Coast Guard boat monitoring traffic on the inland waterway. We disembarked, found a shopping cart, pitched our materials in and began to walk the more than two miles to our house at the other end of the island. We were wearing heavy boots because we had been told there were snakes and rats all over the island, garbage, flooded streets, live wires and evaporating gas tanks. National Guardsmen in vehicles passed en-route but did not stop to give anyone a lift. As we got closer to our home we became more anxious and finally ran the last two blocks pushing the

shopping cart. From the driveway the house looked great. We had to force the door open. Inside, everything was wet. The hurricane had torn off shingles and roofing felt and the rain had soaked the attic insulation, melted sheetrock, collapsed ceilings and water had poured through. We had only enough time to take pictures and throw some plastic over things that might be saved before we had to return to the boat. On the way back, we saw people whose homes had been completely destroyed picking through the rubble to save what they could and others searching neighborhoods to try and find scattered possessions.

The restrictions soon loosened. By Thursday, September 28, residents were allowed to stay on the island from daylight until 5:00 p.m. and to dock private boats at the Sullivan's Island boat landing. The supervised boatlifts were discontinued, but until the Ben Sawyer Bridge was repaired, people continued to make the journey to the island by tour boats, Gulf Stream fishing boats and shrimp trawlers.[58]

THE MARTIAL LAW MYTH

A declaration of martial law constitutes the explicit transfer of governmental authority from civilian control to the military. In democratic societies, such a fundamental change is reserved for the most serious emergencies. In the entire history of the United States, martial law declarations have been extremely rare. And in Hugo, it never happened. There was no declaration before, during or after the hurricane hit. No governmental authority took any action that violated the firmly stated federal policy "that [the] military will support, not control civil government."[59] That reality made little difference. Various authorities had used the term, including statements made during the pre-storm meeting in the Charleston County

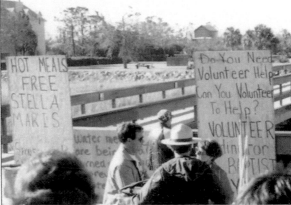

Boatlift (left) and arrival at the Fort Moultrie dock (right). *Courtesy of authors' personal collection.*

Emergency Management Center and by the mayors of the barrier islands. The media consistently said that declarations of martial law had been made. A substitute for the issuance of emergency decrees by local elected officials, the martial law language became the shorthand expression for the emergency operations taking place all over the Lowcountry.

The confrontation between Sullivan's Island town authorities and residents was by no means unique. The considerable body of research into natural disasters and their recovery aftermath has shown that immediately after a disaster, municipal governments face a tremendous overload of decision-making and administrative work. Perceiving only a narrow range of options, officials often act on the basis of cultural myths of maladaptive behavior, particularly ideas that widespread looting and price gouging are omnipresent post-disaster phenomena. Aware of stress and other post-disaster effects on populations, authorities also tend to believe that without external aid and government direction residents in stricken areas are helpless to avoid personal danger and injury or help themselves in meaningful ways. Partly for these reasons, they commonly exhibit

little or no confidence in disaster-affected populations long after the real dangers have ended. People in disaster areas share their own misperceptions. As happened on the barrier islands, when the National Guard or other military units are called in to assist local governments there is a popular assumption that martial law has been imposed.[60]

THE PEOPLE

The cross-section of the more than 250 Sullivan's Island residents and property owners who filled out questionnaires at the beginning of the next (1990) hurricane season does not suggest that those attending the town meetings in Mt. Pleasant were likely to turn into an unruly mob. They averaged approximately 53½ years in age. Nearly three out of four (73.9 percent) were male, more than seven out of ten (71.3 percent) were married and slightly more than a quarter (28.7 percent) single, divorced or separated. More than one-fourth (28.8 percent) were members of dual career couples. Nine out of ten (92.3 percent) owned property on Sullivan's Island, but fewer than half (41.2 percent) of these property owners made the island their primary residence.

On the survey, people had been asked a series of questions about their agreement or disagreement with the decision to bar residents from returning immediately to the island and the imposition of "martial law." A majority (55.1 percent) said that the decisions had interfered with their personal rights to return to the island and examine the damage to their property. A smaller majority (51.2 percent) felt angry and frustrated that they had not been able to return to make necessary repairs. A clear majority (54.6 percent) agreed that the declaration of martial law had been necessary and the right thing to do at the time. A substantial minority, however (46.2 percent), resented the decision to keep people off the island

and thought it had been wrong. The most important distinction was between people who owned property on Sullivan's Island that was also their primary residence and everyone else. The resident property owners had priorities distinctly different from the small number of resident renters (7.7 percent) and those who owned property but did not live on the island. Only by a narrow margin did the resident property owners who agreed that keeping people off the island after the storm had been necessary (46.0 percent) outnumber those who felt they should have been allowed to return to their homes immediately (44.1 percent).[61]

As on the Isle of Palms, the Sullivan's Island community had been sharply polarized at the time of the disaster, and it remained so a full nine months later. (For details on the survey responses see Appendix 2, Tables 3-1 and 3-2.)

The written comments volunteered on the returned questionnaires underlined the strong feelings. Said critics, "Our government failed us all." "The decision (to bar access) was absurd, thieves never could have caused the loss I had because I could not get there." "We need to enforce constitutional right of access to one's personal property." "The National Guard was no help." "Dealing with the primary effects of Hugo, the actual destruction, was not nearly as frustrating as dealing with the total inability of our local government to make rational decisions on behalf of residents' needs." Others expressed their strong support: "I was very much in agreement with [the declaration of martial law on the island] despite my desire to get there and survey the damage" said one. Another added,

> *Repairs could not have been accomplished in the short time people were kept off the island. It was necessary to see the total picture, not individual, personal needs. Officials were elected to represent people and are responsible for making decisions. Any failures can be dealt with in subsequent elections.*

Island in the Storm

In retrospect, it is clear that Hurricane Hugo initially overwhelmed governments at all levels, but with very limited resources small municipalities had the most difficulty in coping. On the barrier islands, consequently, authorities found themselves trying to operate in conditions they considered dangerous without electricity, good communications and the other infrastructure of a modern industrial society. Absent any way to provide medical or other emergency services, they made the quick decision not to allow people to return until conditions were safe.

However correct the decision to bar residents was, it caused a popular outcry, and the barrier island governments were not prepared to deal effectively with the swell of protests. That failure, in turn, raised the specter that people would decide not to evacuate in the face of the next big storm. "I'm not leaving next time around," said an Isle of Palms resident a year later, "Being kept off the island cost me about $40,000."

Fearing the deadly consequences of too many people making such decisions, people began to distance themselves. It was not the governor who refused to reopen the beach, said his office, backpedaling, "It was clear that local governments have the authority to allow reentry." New communications systems were designed. In bullet points, the 1990 Sullivan's Island Disaster Plan prominently displayed its objectives and strategies to

- *Inform residents of island conditions and access to the island in the immediate aftermath period.*
- *Involve residents in evacuation efforts, assessment of island conditions, decisions regarding access to Sullivan's Island in the immediate aftermath and in recovery efforts.*
- *Line up potential resources for assistance to the island and its residents after a disaster.*
- *Establish procedures to assist island residents in returning home after a disaster.*

A later version of the disaster plan sagely advised residents to "Use common sense when hearing reports of massive damage occurring at Sullivan's Island from local media...Ask yourself, 'Now is that really reasonable? Could that really have happened?'"[62]

IV.
THE DAMAGE

Digging Out

The silence which lay over our island
after rage of wind and tide
is broken by the buzzing of chainsaws
and the drone of helicopters,
day after day,
while we below
dig from our mounds of mud;
wet clothes,
books—pages pasted together
with mud forever,
family albums, whose unrecognizable faces
look back at us in watery gaze.

Our memories…
tossed out on the trash heap.

Irene Nuite Lofton

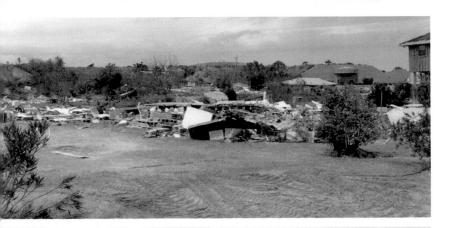

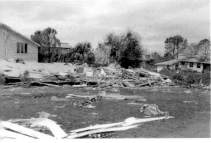
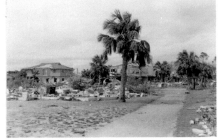

Destroyed homes in the vicinity of Construction 520 (background in the top photo), which was turned over to the Sullivan's Island Township after the closure of Fort Moultrie and eventually became a private residence. *Courtesy of authors' personal collection.*

THE INFRASTRUCTURE

The damage throughout South Carolina was widespread and great. In the twenty-four South Carolina counties that were declared disaster areas, more than fourteen thousand structures had been substantially damaged, the Federal Emergency Management Agency reported. An inventory by the Soil Conservation Service

of the United States Department of Agriculture revealed that some 2,385 miles of South Carolina watercourses were clogged with fallen trees and debris. Surveys by state and federal forest agencies estimated that in the nearly four and a half million acres that represented 38 percent of South Carolina's woodland, more than 8.7 billion board feet of timber valued at more than $1 billion had been destroyed, and the threat of fire was significant. Thirty-five of the forty-eight school districts in the affected counties reported damages to 368 primary and secondary schools estimated at $55.8 million, according to the South Carolina Department of Education. The Clemson University Economics Department concluded that the state's agricultural industry suffered damages in excess of $322.8 million.[63]

When the help did come, it arrived in force. The Red Cross opened 191 shelters to house 89,968 people at the height of the evacuation, and was still caring for 450 people six days later. Red Cross care workers provided mass feeding in the shelters and at mobile outlets for the next thirty days, including one on Sullivan's Island. The Department of Defense sent over 3,000 active duty service personnel to support various recovery tasks. More than 54,000 individuals registered for assistance at FEMA's Disaster Assistance Centers, some 24,755 of them needing temporary housing. The Food and Nutrition Service of the U.S. Department of Agriculture issued over $62 million in food stamps to over 20,000 households and distributed over 814,000 million pounds of U.S. Department of Agriculture food commodities to relief agencies providing emergency food services. The Small Business Administration distributed more than 14,500 home, 6,750 business and 3,400 economic injury applications for low-interest disaster loans. The National Flood Insurance Program received more than 15,000 policy claims. In all, the federal government spent nearly a quarter of a billion dollars on relief and recovery in South Carolina. By the second week after the storm,

some 3,200 soldiers of the South Carolina National Guard would be on duty, joined by 350 members of the U.S. Army's Forty-third Engineer Battalion from Fort Benning, Georgia. A month passed before the last South Carolina National Guardsman went home. By then, some 6,317 Army Guard and 13 Air Guard personnel, nearly half of the state's guard force, had been committed. The peak number on duty at one time topped 4,000.[64]

While the pre-disaster planning had been inclusive and thorough, as the successful evacuation of so many people showed, the planning for the aftermath had provided only the skeleton of the response effort that would be needed. But that structure would prove sturdy enough for the recovery to be mounted. The Charleston County Emergency Council immediately became a working body to coordinate the relief efforts. Each night it brought together the political leadership to review what had been done that day, listen to each other and plan for the next day. And each day it had more to work with.

Seen from ground level, once the flood of assistance started, the results were impressive. A Sullivan's Island resident temporarily relocated to Mt. Pleasant recalled driving down the highway two days after the storm wondering if help would ever come. Within a week, he turned onto the highway and for miles passed a seemingly endless ribbon of parked, olive drab, two-and-a-half-ton trucks filled with troops and supplies. Within days, the line of military trucks was replaced by miles of parked utility vehicles, many with cherry pickers to restore downed power lines, some of the hundreds of trucks sent by fourteen power companies to assist in power restoration. Another resident later remarked, "If you have to experience a natural disaster, you're better off living through it in America."

The most critical infrastructure problem had been getting the roads cleared so emergency vehicles could get through. After that came the electrical grid. Before leaving the state, Hugo had brought down more than twenty-one thousand miles of power lines, enough

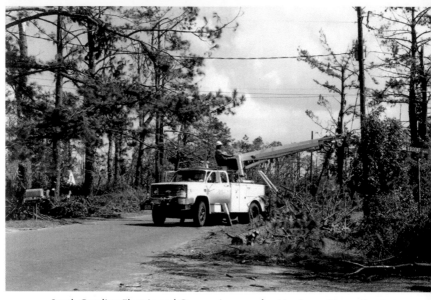

South Carolina Electric and Gas repair crew after Hurricane Hugo. *Courtesy Charleston County Emergency Preparedness Division.*

to stretch from Charleston to Los Angeles seven times. The storm had left between one and one and a half million people without electrical power.[65] Responding to the power company assistance compacts, crews and vehicles began to arrive almost immediately after the storm. As apprentice Lineman Keith Rogers recalls,

> *We were convoyed to Charleston by the highway patrol on Saturday afternoon and started to work. There must have been a good five hundred crews working in Charleston County. I was here thirteen weeks, working up to sixteen hours a day—state law says you have to give linemen eight hours of sleep time—seven days a week. I worked on Sullivan's Island after the bridge was repaired. Before that, equipment was brought to the island by barge and crews were helicoptered in and out. I was so busy and tired that it all runs together.*[66]

The Damage

The early predictions were that it would take months to restore electricity to the East Cooper area. But accompanied by crowds of people who clapped, cheered and waved flags when the crews appeared, the power companies restored electricity in seventeen days.

Clearing the main thoroughfares so emergency vehicles could reach people and the power crews could restore electricity meant that lesser-used highways, side streets and suburban streets would have to wait. But in neighborhoods across the county, something fascinating was taking place. There is considerable criticism of America's "consumer culture," including the derision that people have too many "toys." But the toys included tractors, generators, winches and most visibly after Hugo, chain saws. They ran everywhere all the time as chainsaw armies of citizens cleared the smaller roads, the back streets, the side streets and the cul-de-sacs almost as rapidly as the city and state crews cleared the main thoroughfares. This effort came at a price. "There were so many injuries from people using chain saws that the hospitals became seriously overloaded and were not able to handle other emergency cases," says County Council Chair Lombard. "The hospitals asked County Council to broadcast appeals for people to stop using them."

From afar, the dislocated barrier island residents could see all that was taking place to get life back to normal. But until the connection to the mainland was restored, it could not happen where they lived.

THE BRIDGE

The most visible casualty of the hurricane was the Ben Sawyer Bridge, one end mired in the waterway, the other end high in the air. It was also the most critical infrastructure problem confronting Sullivan's Island and the Isle of Palms. Until the bridge was repaired and the connection to the mainland reestablished, the first recovery steps could only be slow and awkward.

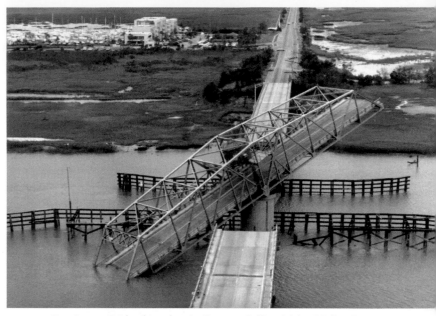

Ben Sawyer Bridge from the air. *Courtesy Sullivan's Island Police Department.*

Everything going to the barrier islands now moved by water or air. Early on September 23, personnel at the Fort Sumter National Park began securing the Fort Moultrie dock, the only docking structure available on Sullivan's Island. The Park Service dispatched two additional law enforcement rangers to assist in maintaining twenty-four-hour dock patrols to prevent unauthorized use and authorized the activation of an emergency helicopter landing zone at Fort Moultrie. It was used to ferry people with disabilities and older residents, military and emergency personnel and visiting VIPs such as Governor Carol Campbell Jr. and the Reverend Billy Graham.

Responding to a request from the South Carolina Highway Department for technical assistance, on September 23, the Charleston District Corps of Engineers mobilized a damage assessment team to inspect the bridge and evaluate alternative solu-

tions to restore traffic flow to the islands as quickly as possible. The team discarded the idea of constructing a temporary floating ribbon bridge and a marsh road the first day because there were no feasible bridge approaches and the project would be too costly. But by September 25, the Charleston District was able to tell the South Carolina Highway Department and FEMA that it had a bold plan to restore the span to a fixed position within one week. The Corps also asked to be given the project, and approval quickly followed. Working late into Sunday evening, district personnel completed a streamlined procedure to let a contract to shift the Ben Sawyer Bridge span to a level position, support it with temporary bracing on barges and set it back in place. The expedited bidding process resulted in the quick award of a contract, but not before a major obstacle was overcome. Because the temporary repair to the Ben Sawyer Bridge would obstruct navigation on the Atlantic Intracoastal Waterway, the Coast Guard strongly opposed the project the Corps had recommended. It took the intervention of Senator Fritz Hollings to overcome the Coast Guard's unexpected and intense objections.[67]

Wednesday, September 27.

We are not allowed to return to the island today. It has been raining hard since the hurricane. I spent the day arranging to get 25 rolls of 30# roofing felt for an emergency roof cover to stop the damage the rain was doing. I finally found 25 rolls at Lowes on Coleman Boulevard, but they would not hold them. Even though I was still ill with the flu and had very little voice I walked the more than two miles to get the last rolls. My husband has been out with the car lining up items we needed to take to the island. When he returned, I drove him to the bus station where he caught the 5:15 bus

to Columbia to pick up our old Oldsmobile. It had the only trailer hitch for our boat but the brakes had completely gone out in the evacuation to Columbia. We will take the roofing felt to the island tomorrow by boat.

The repair effort began September 29, exactly a week after the hurricane had struck. Despite the lack of original construction drawings, weather delays, equipment problems and the serious constraints that natural tides placed on the project, the repairs proceeded rapidly. The challenge of maintaining safe working conditions (there were no injuries on the job) required a policy that emphasized safety over time. Completion of the work took only slightly more than a week. With the help of the tides, barges moved the bridge back into position early in the morning of October 6. In the afternoon, the Ben Sawyer opened to one-way traffic for vehicles weighing less than ten tons. The emergency portion of the work complete, the Corps of Engineers turned the structure over to the Highway Department, which awarded a contract to repair the damaged turning mechanism. The Ben Sawyer opened to two-way traffic on December 15 and the permanent repair of the bridge was completed on December 21 when daylight operation of the swing span resumed, permitting the passage of navigational traffic. "It was an opportunity to make a difference," Corps officials later said. "Our staff of engineers, managers, and contract specialists knew that they could get people back across the bridge to their homes."[68]

HOMES

Some of the residences that structurally survived in the best shape were among the oldest. A number of the residences constructed on the western end of Sullivan's Island dated back to the late nine-

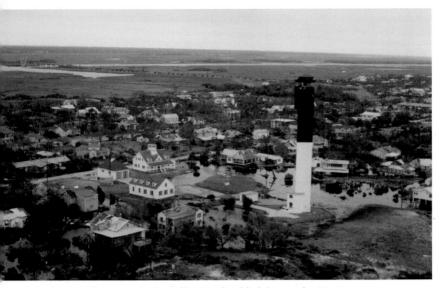

Aerial view of homes near the Sullivan's Island lighthouse after Hurricane Hugo. *Courtesy Sullivan's Island Fire Department.*

Photograph taken from the Sullivan's Island lighthouse approximately one month before Hurricane Hugo. *Courtesy Carl Smith.*

teenth century. In all probability, anyone building on the island at that time would have been familiar with what natural disasters could do, and perhaps built accordingly. Category 3 hurricanes had hit Charleston in 1885 and 1893, a Category 2 in 1911 and a weakening Category 1 two years later. The great Charleston earthquake of August 31, 1886, a magnitude 7.6 on the Richter scale, the strongest recorded strike in the eastern United States that was felt from Cuba to New York and Bermuda to the Mississippi River, damaged 90 percent of Charleston's brick structures.[69] Generational memory carried this knowledge into the 1930s. Notes Building Official Randy Robinson, "some of those homes have thick steel rods bolted at the ends running through them, probably the result of experience with the earthquake. Turn of the century construction practices were also different. Building materials included cypress, and the post and beam construction that produces strong frames."

Seventy years passed between the Great Earthquake and forty years between the hurricane of 1911 and the arrival of Category 4 Gracie in 1959. In the interim, new, less costly construction techniques such as stick framing and setting foundations on concrete blocks or slabs were employed. Some of the resulting buildings were less sturdy. As the pictures of the damage on the Marshall Reservation at the eastern end of Sullivan's Island clearly show, how buildings there fared depended in large part on whether they were constructed before or after the adoption of a strict and enforced building code.

The code itself had federal origins and local colorings. In 1962, an unusual Atlantic storm began as a weak circulation along a cold front, moved seaward of the Carolina coast, deepened, partially merged with a storm center moving from the Midwest, migrated northward, spread out to encompass the eastern third of the United States and a large area in the western North Atlantic, became elongated along an east-west axis, developed two centers, began to generate powerful waves and finally rode five spring tides inland to

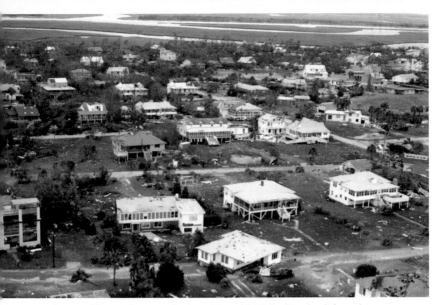

Aerial view of homes between Stations 28 and 28½ looking back from the beachfront. *Courtesy Sullivan's Island Fire Department.*

spread damage from Nova Scotia to Miami Beach. The strongest storm on record to strike the eastern seaboard, it was followed in September 1962 by Hurricane Betsy, the most destructive hurricane on record, which crossed the Gulf Coast near Grand Isle, Louisiana, with 160-mile-per-hour winds, gusts to 180 miles per hour and a 22-mile-per-hour forward speed; 81 people were killed and 17,600 left injured.

The twin disasters triggered interest in reinvestigating the need for a federal program of flood insurance. Adoption of such a program required answers to two tough questions. The first was to make flood insurance affordable and to get people to buy it. The problem was that people living on mountaintops and other places immune from flooding would not buy flood insurance because they would never need it, which meant that, in flood-prone areas, the

price of policies would be so high that people who did need the insurance would be unlikely to purchase it. The second question, how to control the upwardly spiraling taxpayer-born costs of flood control protection, was even more acute.

Federal expenditures to provide protection from flood damage originated in the aftermath of the 1927 Mississippi River flood, and for the next fifty or so years protective measures consisted principally of various government agencies such as the Corps of Engineers and the Interior Department building dams, levees and other structures. The problem was that as soon as levees or dams were erected to control flooding, development crowded into the newly protected flood plain, and, if an extreme flood event occurred, the loss was greater than if the structure had never been built in the first place. This happened because, for reasons of cost, structures could never be built to a scale that would enable them to deal with an event such as a major flood that might arrive only once every one hundred to five hundred years. Dams and levees were therefore built to a scale that would protect from the more frequent lesser events. But from 1945 on, as an increasing number of flood control projects were completed, more and more people crowded into the flood plain. Soon, a maximum event was happening somewhere in the country nearly every year. Federal flood control expenditures and costs to the taxpayers rose steadily. By the 1960s, to this outlay was now being added greater political pressure for even more protection from floods and hard-to-ignore demands for federal relief assistance after a disaster occurred.

To begin controlling costs, in 1968 Congress enacted the National Flood Insurance Act, creating the Federal Insurance Administration within the Department of Housing and Urban Development. The idea was to reduce losses from flooding by combining in one program land use management, strong building codes and insurance. It would take five more years and another string of major disasters before an effective legislative package was put together, in

the Flood Disaster Protection Act of 1973. This legislation specified that as a condition for obtaining a federally guaranteed mortgage, such as a VA or FHA mortgage, or a loan from a financial institution whose deposits were guaranteed by the federal government, anyone constructing or purchasing a building in a flood prone area had to buy a flood insurance policy. To hold down costs, the policies were subsidized by the federal government and sold only in communities that had adopted construction codes that met or exceeded federal standards. The program took time to implement. The nation's flood zones first had to be identified and mapped and a number of other details had to be worked out. Nevertheless, passage of the act marked an important reorientation in federal flood control policy. While primary responsibility for managing the flood plains still remained with local government, development in these hazard zones was now to be guided.[70]

In 1972, South Carolina enacted legislation that enabled jurisdictions to adopt building codes that required use of the latest editions of the Standard Building Code and the National Fire Protection Association standards. The legislation also created an autonomous state agency, the South Carolina Building Code Commission, to oversee the use, adoption and interpretation of local building codes and standards to approve any modifications.[71] Consistent with the requirements of the federal statute, Sullivan's Island adopted a building code, its first, in 1977. The code required the elevation of all living space to a predetermined level above mean high tide, fixing the building's foundation with telephone pole-length pilings or steel-reinforced concrete block pilings tied to a similarly constructed foundation grid, the use of nails, steel strapping and hurricane clips to hold the building together and more. But the program was new; South Carolina had yet to require that building inspectors be certified, and in any case the township did not have anyone to go on site to verify that what had been constructed was what the plans

called for. The violations were numerous, and in August 1982, the township was cited and put on probation by the Federal Emergency Management Agency. The threat of not being able to participate in the federal flood insurance program was acute; among other things it meant that people might have to pay their federally guaranteed loans and mortgages immediately. Sullivan's Island quickly made the necessary corrections.[72]

The effect of the enforced building code was to create a new class of buildings: conforming, meaning structures built to an enforced code, as opposed to non-conforming, meaning a number of older dwellings. Hugo demonstrated that the Sullivan's Island codes were basically sound. (This was true all along the coastline. Most well-engineered, well-built structures sustained structurally, though they lost decks, access ladders and ramps.[73]) As a rule of thumb, buildings that were knocked off their foundations or totally destroyed predated the enforced new code while buildings that had survived Hugo more or less structurally intact had been built after 1982, with the exception of the older residences at the western end of the island. Land and aerial photographs looking inward from the beach at the eastern end of the island near Breach Inlet show the distinctions clearly. Piles of concrete block foundation rubble, houses blown down or floated off their foundations or homes severely damaged by wind are in contrast to homes atop deep pilings, the type of foundation that performed consistently well.

But appearances can be deceiving. Many of the dwellings that survived Hugo in good shape structurally continued to suffer as the post-storm rains penetrated through damaged roofs.

Thursday, September 28.

The rules have been changed. We are allowed to be on the island until curfew and can travel by private boat. Jim

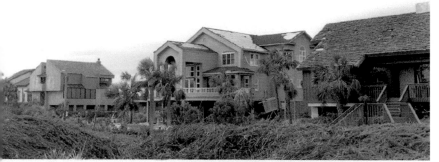

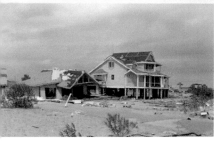

Residences on the Marshall Reservation that survived Hurricane Hugo structurally intact and one (lower left) that did not. *Courtesy of authors' personal collection.*

Harper, a contractor, and I picked up the roofing felt and life vests I had purchased in Columbia. My husband put the boat in the water at the public boat landing at Shem Creek only to discover that the engine had been damaged from the heavy rain storms following Hugo. While he was getting the boat back to shore I was able to rent a pontoon boat. It was now past 11:00 a.m. and we had to be off the island by 4:30. We landed at a private dock about a station and a half from our house. I managed to flag down an old car to carry four rolls of the roofing felt to the house and later a jeep to carry the remaining 21 rolls. Jim worked steadily on the roof all alone. The wind rose. I tried to get some volunteer help, but

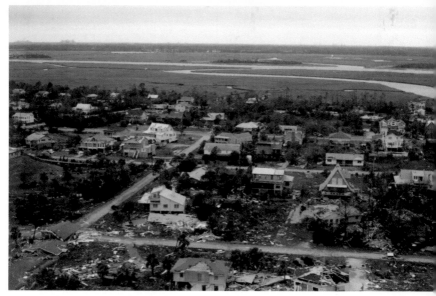
The destruction between Stations 29 and 30. *Courtesy Sullivan's Island Fire Department.*

I was told that none could be given to private citizens. My husband worked inside the house, carrying insulation that had crashed through the roof and soggy clothing and bedding to dry. I spent all my time clearing the rotten food out of the refrigerators and trying to clean them with Windex. There was no water. We both spent time moving furniture out of areas where the ceiling was dripping and covering furniture that had not been damaged.

V.
THE INSURERS

No insurance company in the world could have been adequately prepared.

The person in charge of the claims office [in another state] did not seem to understand that our property was on a barrier island and we could not begin to salvage anything for over two weeks.

Sullivan's Island residents

For many people, their most important financial contact after the hurricane was the insurance adjuster. As after an automobile accident, suddenly the arcane language of an insurance policy, some complete with fine print, had a human face, a person who explained, interpreted and often refereed what the words meant.

How did residents and property owners on Sullivan's Island find this experience? Within nine months, one out of three had changed companies and one in eight had disputed a company's settlement offer by hiring an attorney, engineer or mediator, writing the state insurance commission or contacting the media.

Disaster studies are relatively common. A number examine questions of whether or not the affected victims carried insurance and how well insured they were. State agencies review the post-storm performance of the companies they license and issue reports. But the responsiveness of insurance companies after a major natural disaster from the consumer's perspective is unstudied. The research difficulties are enormous, and seldom does an occasion arise where the actual delivery of insurance services to customers under the most difficult conditions can be compared to the promises companies make and the reasons people bought their policies. Hugo offered a unique opportunity to learn more about this process.

Insurance is big business. In 1987, the highly competitive industry contributed $101 billion to the gross national product and employed some 2.2 million Americans, more than automobile manufacturers and services. In the multi-billion dollar property insurance segment of the industry, companies compete to sell policies using advertising and promotion strategies that remind people of the disasters and tragedies that may occur. They encourage potential customers to think that this one particular company will personally care about them and be on the spot immediately to help in time of need.

Most of the time, the filing of an insurance claim is an individual matter, done in isolation from neighbors. Fire, theft, automobile and casualty losses are the most common circumstances. But nearly every American community is at risk from some type of natural hazard, and many are exposed to multiple hazards such as flooding, fires and tornadoes. For insurance companies, their most severe test is posed by the extreme conditions of a major

disaster that simultaneously affects a large number of people in a single region in a short period of time—the shorthand description of a major hurricane. They are aware that each year the potential for a major hurricane disaster increases dramatically, a result of increasing population density, migration to the hazard-prone coastal regions and the rapid growth in the numbers of elderly, disabled and poor in the population. Consequently, companies put a great deal of thought and planning into dealing with unscheduled disaster events.

Hurricane Hugo confronted insurance companies with the greatest property loss from any natural disaster in American history to that time. By one standard, they performed very well. In an effort the South Carolina chief insurance commissioner later called "the insurance industry's finest hour," companies rapidly mobilized resources and in a relatively short time sent some 3,600 adjusters into damaged areas to competently handle some 340,000 claims. The industry and government perspective, then, is that after Hugo the insurance companies successfully lived up to their promises. [74]

The Sullivan's Island survey examined the delivery of insurance services from the viewpoint of people who bought the policies. Outside the public emergency agencies, insurance companies represent one of the most crucial contacts for people affected by a natural disaster, so how individual companies performed in individual cases matters a great deal. After Hurricane Hugo, did performance match the promises? If, as their advertisements say, customer satisfaction is their major goal, did insurance companies deliver after Hurricane Hugo?

How to measure customer satisfaction is an important question. If, as the cliché states, customers are always right, one must know what they are right about. Customer satisfaction can have many meanings. At the time insurance is purchased, it may mean simply that the customer is satisfied with the price. In the event of major

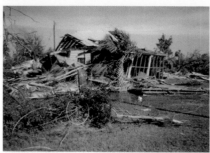
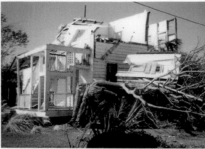
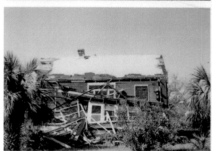
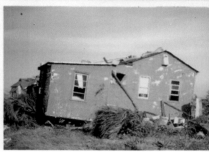

Older homes on Sullivan's Island that did not survive Hugo. *Courtesy Sullivan's Island Fire Department.*

loss, satisfaction can mean something else entirely. Balancing the two elements is important.

Property damage is the most visible and measurable impact of a modern-day natural disaster in the United States. Losses of substantial long-term investments in homes and businesses are damaging both financially and psychologically. Widespread loss affects entire communities. The most common finding in post-disaster studies is what people did not do. Some homeowners did not seriously evaluate their needs or make plans for the event against which they purchased insurance. Not all collected sufficient information beforehand to evaluate the costs and benefits of alternative courses of action when buying insurance. Homeowners did not keep up with the appreciation in property

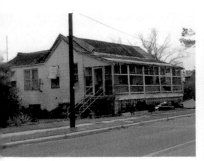
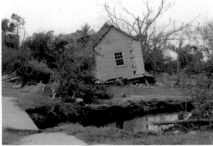
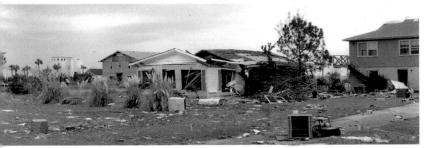

Three houses affected by the storm surge. *Courtesy of authors' personal collection.*

values or take such pre-disaster measures as inventorying possessions and keeping records in a safe place. But the biggest mistake by far is the failure to purchase flood insurance. People commonly buy insurance policies to protect against fire or wind damage. But flood damage is responsible for about 80 percent of the property losses in the United States, and even though affordable flood insurance is available, people do not routinely purchase it. Today, over eleven million people live in high-risk flood plains, defined as a 25 percent probability of flood damage over the standard thirty-year mortgage. But only one homeowner in four in the high-risk areas has flood insurance. Even in the country's higher risk zones, participation in the federally subsidized flood insurance program is not nearly as widespread as people suppose. And as many as half

of all private homes in the country's highest risk flood zones may be uninsured. This can be an acute problem for renters as well as homeowners, because many who rent assume their personal property is covered in the rental contract.[75]

For the policyholder, filing an insurance claim after a disaster can prove trying under the best of circumstances. Any lapse of judgment in acquiring pre-storm coverage compounds the problem. Insurance companies pay only under the terms in policies and have a strong incentive to define exposures in precise language. Exclusions and exceptions may be discovered only after an emergency when the policyholder reads the fine print for the first time. Concerned about fraudulent claims, companies can be excessively careful, frustrating honest policyholders who expect prompt action. The absence of inventories, photographs and proofs of ownership can open up areas of disagreement. As a result, some disaster victims find their perceptions of coverage do not match reality:

> *I was led to believe that I had replacement value when in fact, because the house was not my primary residence, I got much less.*
>
> *Make the bad faith statute clearly applicable to catastrophic situations and property insurance claims.*
>
> *Dealing with insurance adjusters is the pits.*

Sullivan's Island residents

While some studies suggest that major disasters do not lead to long-term community economic losses, the fact that numbers of individuals get badly injured financially is beyond dispute. When people buy a policy from a particular insurance company, among

other things, they are responding to what they infer is an implicit commitment of the company to deliver the promised services in time of need.

Insurance carriers, at least in part, have pre-programmed policyholders to believe that they have been educated about their insurance coverage and, after a loss, to anticipate quick responses, expeditious handling of claims and professionalism on the part of the insurance claims handlers with whom they must deal. From the consumer's perspective, the degree to which an insurance company carries through in dealing with the full range of problems faced by policyholders after a major disaster is the measure of organizational effectiveness.

As described earlier, none of the approximately 923 buildings on Sullivan's Island escaped damage from Hurricane Hugo. The insurance experiences of island residents varied widely. Nine of every ten had wind or homeowner's insurance coverage and nearly two-thirds carried flood insurance on buildings. But fewer than half had their personal property insured against flood damage. Although three claims out of every four were settled within four months, only half of the people said they were satisfied or extremely satisfied with their settlements. Only one policyholder in four said that before the storm they had a full and informative discussion about their coverage with an insurance representative. Only one in five said they had been made fully aware of the difference in coverage from wind damage and flood damage. This proved to be an important distinction in the early days of the recovery when numerous policyholders without flood insurance were told by carriers that their home had been damaged or destroyed by water and not wind and vice versa.

Was the wind or the tidal surge to blame? In the case of dwellings that were totally destroyed or off their foundations and badly damaged, at first glance it seemed hard to tell, and some poli-

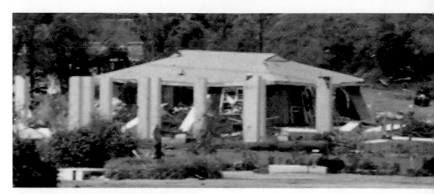

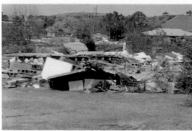
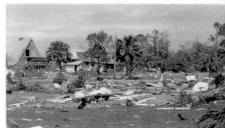

Wind or water? Damaged homes on the Marshall Reservation off their foundations. *Courtesy of authors' personal collection.*

cyholders found themselves dealing with recalcitrant adjusters. Many of these disagreements were resolved after teams of volunteer civil engineers from Clemson University, The Citadel and elsewhere presented in an open meeting convincing evidence that the critically important initial structural failures were caused by the high winds that blew out windows and doors, removed roofs and collapsed walls, after which the tidal surge scattered the debris.

Slightly more than one-third of the policyholders had flood insurance coverage for their homes, but in this group only one in four had the necessary flood insurance for contents, which is sold separately. Sullivan's Island is a flood zone; however, only two

people out of every five knew whether they lived in an A Zone (areas prone to flooding) or the more dangerous V Zone (flooding plus wave action).

Damages and losses to homes ranged from minimal (9.6 percent of homes) to completely destroyed (4.8 percent of homes). About half of the residences (45.4 percent) were partially or severely damaged, but remained habitable. Four out of ten (40.2 percent) were so badly damaged they could not be lived in. Four residents out of ten (40.5 percent) calculated their property loss to be under $40,000. Not quite half (46.8 percent) said their property losses were $40,000 or higher. To these figures were added the dollar losses of personal possessions, which ranged from none (8 percent of residents) to less than $10,000 (39.4 percent of residents) to $10,000 or more (39.3 percent of residents). In the first year after Hugo, some six hundred building permits totaling nearly $15.7 million were issued on the island. (See the tables in Appendix 2. All figures are in 1989 dollars. To convert to 2006 dollars, multiply by 1.6.)

Settlements were complicated by the difficulties that insurance companies faced in responding after the storm. One policyholder in five had to wait over a month to talk with an insurance company representative. More than half had to deal with more than one adjuster. One in four said that their adjusters disappeared and were replaced without any notification. More than 25 percent said the information they got differed from adjuster to adjuster. Asked to identify events that had most severely affected their lives, such as a death in the family, divorce or changing a job, more than one-third of the people put dealing with insurance company representatives at the top of their list. As a community problem, insurance-related stress ranked behind increased demands on one's time and problems in rebuilding one's home but ahead of the difficulty of dealing with the death of a loved one or friend. One policyholder in three

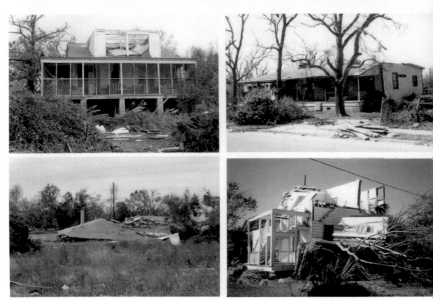

Four homes showing extensive wind damage. *Courtesy of authors' personal collection.*

coped by going over the head of an adjuster to speak to an insurance company supervisor, one in six threatened to get legal assistance or go to the state insurance commission and one in seven obtained the services of a professional engineer to substantiate storm damage claims.

Three out of every four residents (73.4 percent) had losses that were not covered by insurance. They ranged from less than $9,999 (29.9 percent) to between $10,000 and $20,000 (16.8 percent) to $20,000 or more (26.7 percent).

Within four months, three insurance claims on Sullivan's Island out of every four had been settled and nearly half the policyholders said they were satisfied or extremely satisfied with their settlements. But one policyholder in four was either neutral about the settlement or dissatisfied to some degree. More than one-quarter said

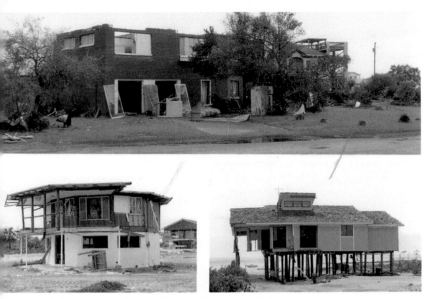

Marshall Reservation homes damaged by wind and the storm surge. *Courtesy of authors' personal collection.*

they would not be compensated for major losses they thought their policies had covered. Not surprisingly, dissatisfaction with insurance companies correlated strongly with the dollar amounts of property damage and uninsured loss. The fact that one-third of the people said they had increased their coverage since the hurricane, most commonly between 10 and 20 percent, is perhaps a good measure of heightened awareness.

Some thirty-two major insurance carriers served Sullivan's Island. Six of these (American Mutual, Continental, Nationwide, South Carolina Wind, State Farm and USAA) had ten or more Sullivan's Island policyholders. State Farm represented 22 percent of the market, Allstate 15 percent and the Nationwide Group 7 percent. These three insurance carriers were also the leading insurance carriers in South Carolina. Statistical analysis demonstrated

support for the proposition that, among those insurance carriers that represent the largest number of consumers, the best predictor of perceptions of insurance company effectiveness in handling the claim was the length of time it took an insurance company to get in touch with the policyholder, the progress of the settlement, the number of adjusters or insurance company representatives with whom people had to deal and how much the policyholder knew about his or her coverage prior to the disaster. Fast insurance company response and good communication with policyholders positively affected the insurance company effectiveness score. Having to deal with a number of insurance adjusters over a long period negatively affected ratings. Among the carriers, Nationwide Insurance Company had a statistically significant positive rating for reaching a final settlement and State Farm had a statistically significant positive rating for responsiveness.[76]

Satisfaction with insurance carrier settlements tended to vary by one's level of damage, whether or not one had to deal with more than one insurance company and the amount of uninsured loss, but these factors were not absolute predictors of individual experiences.

The most satisfied policyholders were those whose damages totaled less than $50,000. Within this group, people who had either damages of $25,000 or less or had few uninsured losses (or both) were the most satisfied, despite the fact that on average they were out of their homes longer and received their final insurance settlements later than did others. How this group rated insurance company effectiveness depended on the number of family members in residence, age and how quickly they received the first settlement. Interestingly, they had also lived on the island longer.

The least satisfied group of policyholders had damages between $50,000 and $100,000. They evaluated insurance company effectiveness based on how responsive the company had been immediately following the storm and how assertive they had to be to

get a fair settlement of their claim. Slightly more than a majority (52.6 percent), generally those with the greatest levels of damage and most uninsured losses, had to threaten to take action to get settlements they thought appropriate. Of those who threatened, four out of ten (40.8 percent) actually carried through to engage an engineer, attorney or mediator. These policyholders were also more likely to feel that they had been given insufficient pre-storm information from insurance representatives regarding their coverage. It should also be noted that many were living in their badly damaged homes while they were being repaired.

People with damages exceeding $100,000 were in the middle of the satisfaction index, significantly more satisfied with their settlements than people in the $50,000–$100,000 group but less satisfied than people in the group with losses under $25,000. The high loss group judged effectiveness on how quickly the insurance company responded and the number of different adjusters with whom they had to deal. Though moderately satisfied with the settlements, as a group they rated insurance company effectiveness in dealing with their needs extremely low. It should be noted that a majority of these policyholders did not live on the island full-time.

In general, people with higher levels of damage and loss and greater uninsured losses were confronted by more problems, had to battle harder to obtain settlements and reported less satisfaction with insurance company treatment than those in the lowest level of damage group. People who had to deal with two insurance companies were less satisfied with their settlements than those with one company. But overall, the most important ingredient in customer satisfaction depended on whether or not property damage from flooding was covered.

Many settlements did not come stress-free. A number of people had to threaten to take some action (get an attorney, contact the

media, write the state insurance commission, hire an engineer, etc.) and 12.7 percent of these actually did one or more of these things to obtain a satisfactory outcome.

After the hurricane, Sullivan's Island residents were more apprehensive about a repeat event, more willing to comply with land and building codes and more likely to seek out evacuation routes ahead of time. They had talked more with their insurance companies, broadened the types of coverage and made significant changes in their homeowners, wind and flood insurance coverage. They now spent time learning a great deal more about what their policies said. This was particularly true among people who had increased their insurance coverage. Many also felt it was important to increase their comprehensive insurance coverage and add an earthquake rider, contributing to decisions to change carriers.

Stressful insurance experiences provoked many comments. The most common was that policyholders needed more and better information. "Coverage should be thoroughly explained to homeowners," said one. "Make insurance agents sign off whether all elements of coverage were explained and offered when writing policies," suggested another. Then there was the homeowner who said, "I didn't notice items that were damaged until six months after the storm. My insurance company had given me what appeared to be a healthy settlement, and I didn't want to bother to reopen the claim." And many residents were critical of adjusters at the boat landing who were offering quick settlements to residents who clearly had not had time to evaluate their damage and were also in a vulnerable position as their possessions had been destroyed and they were in need of quick cash.

The experiences of Sullivan's Island residents offer compelling evidence that untreated pre-disaster issues became major post-disaster problems. The fact that people with lower levels of unin-

sured damage were among those most satisfied with their settlements is a finding that may be more significant and less obvious than it appears. People whose damages were covered by insurance also reported fewer problems in understanding the provisions of their policies, and more than half of these policyholders felt that their insurance companies had informed them accurately about their coverage prior to the storm. Consequently, less than one-fourth of this group had to take assertive actions to get a settlement. As this group had lived on Sullivan's Island longer than any other, their experiences may have several implications. Perhaps, as noted in an earlier chapter, they lived in well-built older homes that could ride out the hurricane. Perhaps the agents who sold these policies in the first place did a better job of explaining what they needed. Perhaps these residents had prior experience with hurricanes or had heard family stories. Or maybe they were just lucky. But as a group they differed significantly from policyholders who had large uninsured losses, felt they had been influenced badly by their insurance agents in policy selections and reported that they had not been completely informed about the exact terms of their coverage.

While the individual problems people experienced included inadequate insurance, policies with more than one company, leading to attempts at loss shifting or the lack of records to prove loss, the most common and expensive error people made was the failure to purchase the separately sold flood insurance to cover both property and possessions.

Less common but critical to some were the cases where insurance coverage had not been increased to keep up with rising property values and construction costs. This may be an even greater problem today. In 1989, most blanket homeowner policies paid, after the deductible, the entire replacement cost of repairing or reconstructing the residence as it was. In recent years, many insurance

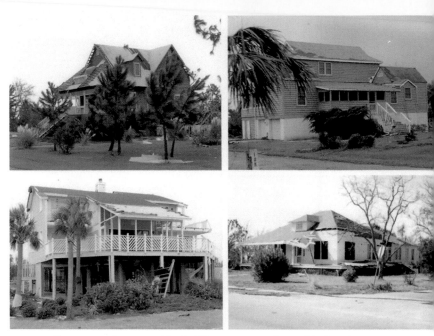

Three newer homes on Marshall Reservation and one older beach cottage
(lower right) exhibiting high structural integrity but major roof damage.
Courtesy of authors' personal collection.

companies have limited their liability by defining replacement cost
to mean the dollar amount specified in the liability section of the
policy plus a fixed percent (commonly 20 percent). Because prop-
erty values on Sullivan's Island have risen dramatically in recent
years—so much so that in 2005 the island was profiled in the *New
York Times*—and as construction costs also increased in recent years,
the fixed dollar amount of maximum coverage may not cover the
cost of a home's replacement.[77]

The damage Hugo inflicted on homes on Sullivan's Island nearly
always included the need for roof repairs, even for homes built to a
code that required metal roofs of precise specifications or twenty-

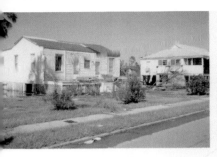
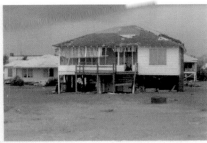
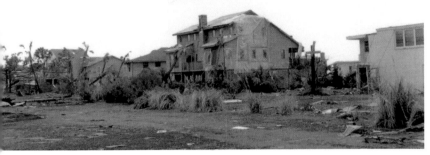

Temporary roof repairs. *Courtesy of authors' personal collection.*

pound or forty-pound roofing felt and high quality shingles. (Since Hugo, it has become easier to increase structural protection by exceeding the building code requirements by utilizing new materials like ice shields and thicker, stronger metal roofs that maximize protection from wind.)

The unexpected Hugo event may also be an insurance warning. The South Carolina Lowcountry sits on top of a geologic fault that cannot be seen on the surface of the earth. There is a 40 percent chance of a large earthquake in the eastern United States within the next thirty years and a 60 percent chance of a magnitude six or better.[78] Like coverage for flooding, earthquake insurance is sold separately.

Island in the Storm

Patchwork Roofs

The buzzing
of chain saws
has changed
to the happy tapping
of roofers.

I watch
as orange, blue and green tarps,
bright Bandaids
to keep rain out,
give way
to shiny tin
reflecting sun and sky.

Hope is in the air.

Irene Nuite Lofton

VI.
STRESS

Feelings? Indifference, intolerance, suspicion, distrust, anxiety, everything that goes with a disaster.

It was much easier to get over the death of my spouse than to get over Hugo.

Sullivan's Island residents

Getting back, seeing the destruction, traveling back and forth to begin to put the pieces together, making the new living arrangements dictated by circumstances, maintaining work and family life and trying to balance everything. That was just the beginning.

Kind people did all they could to ease the burden. Pastors of the Sullivan's Island and Isle of Palms churches got together and divided responsibilities among them. The East Cooper Council

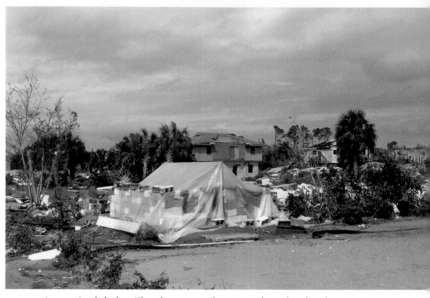

Improvised shelter. The photo was taken several weeks after the storm.
Courtesy of authors' personal collection.

of Churches and the Red Cross established a community kitchen at Stella Maris Catholic Church, which was powered by a generator borrowed from the North Carolina National Guard. The cooking crew was ferried to and from the island by the National Park Service boat until the Ben Sawyer Bridge was repaired. The all day cafeteria serving line featured Baptists, Presbyterians, Episcopalians and a rich variety of other denominations.[79]

The Stella Maris Church brought its school bus to the island from Mt. Pleasant. No driver was available, so Father McInerny was pressed into service. It had been twenty years since he had driven the bus as a high school student. His first task was to roll the bus onto a barge from the landing at Gold Bug Island over a ramp so narrow you could not see it. He had to be perfect. The bus ran all day long from the Fort Moultrie Dock to Breach

Inlet and back. "People would get on with trash bags," Father McInerny recalls.

> *They were going to collect their possessions. The bus would stop and you would let people off and most you didn't see for hours. Then you would drop people off and they would be waiting at the bus stop when you made the next trip. They had nothing left. That was the saddest experience.*

The Salvation Army set up a plastic tent stocked with water and supplies free for the taking at the convenience store across from Dr. Durst's office. It was manned by the army and volunteers. One was an out-of-state U.S. Army major, home on leave from Europe, who had come to the island to look after his parents' property. Their home had been completely destroyed, so he stayed on to work at the tent.

Sunday, October 1.

> *We don't have to walk to the house from the Ft. Moultrie dock any more. There is a school bus that goes from one end of the island to the other all day. We discovered serious water damage upstairs. All the winter clothes were wet. We carried these into the sunshine to dry. My husband shoveled pluff mud out of the entry and stairs. Our son came from the University of South Carolina and the three of us worked all day Saturday and Sunday pulling out wet insulation. It rained and rained. We keep discovering damage to walls, woodwork, doors, flooring, ceilings, fans, you name it. Water pours out of light circuits in the baths, halls and bedrooms. Soaked sheetrock is collapsing everywhere. The mildew on the*

rugs began to grow into a fungus so we pitched them out. Still there is no water, power or sewage disposal on the island.

A Marshall Reservation resident took time off from damage control to make videotapes of other people's damaged homes, furniture and possessions so they could show them to the insurance adjusters when they arrived. The tapes were helpful. The first adjusters on the scene could see the damage for themselves, but by the time their replacements arrived people had cleared out most of the water-soaked clothing, furniture and other possessions to make the house habitable. Few of the new adjusters wanted to view the tapes. Just having one in hand and offering to show it was enough.

Wednesday, October 4.

The two weeks the bridge has been tilted into the water is a constant reminder that life is not normal and will not be for a long time. The changes penetrate in waves as the demands increase. We are still told that the island is under Martial Law with a 7:00 curfew. It is impossible to reach anyone on the island by phone. There is no electricity. Water was restored two days ago but is unfit to drink.

The cleanup went on and on for weeks that dragged into months against the backdrop of whining chain saws. On the islands, depressing heaps of debris on the side of the roads grew larger every day. Finding a new place to live or fixing up a damaged residence took time and energy. Job commitments had to be met. Children needed attending. It went on and on while the hurricane

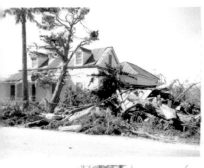

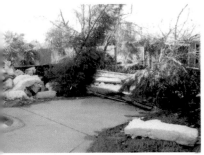
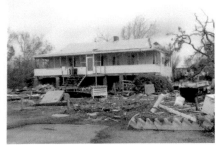

Early scenes of storm-scattered debris (top left and bottom right) and debris from the cleanup filling a driveway (bottom left) and set out on the street (top right). *Courtesy of authors' personal collection.*

became old news and people elsewhere went on to other things. It is called stress.

Thursday, October 5.

Today we left for Sullivan's Island from Patriots Point. We caught a ride from the boat dock on Sullivan's Island in a van that had been left on the island during the hurricane and flooded by salt water. The driver was using a string attached to the carburetor as his accelerator pedal. All day we inventoried damaged possessions in the house. We had a garbage pickup.

127

We caught a ride on a fishing boat back to Shem Creek where I waited for my husband to walk back to get the car so we could pick up our dog from the vet. We feel we are among the people who are well off and are sad for the devastating losses suffered by others. Many have lost everything and have no insurance coverage. We have seen a family who found their house had escaped total destruction from the wind but the rains pouring through the open roof had spared nothing. Their once beautiful dining table still held the place mats and plates but the mahogany table top was white from days of standing water. The man was sorting through the rubble. His wife could not bear to look. She kept repeating, "I will never come back." A large number of houses have been totally destroyed, some moved off their foundations to be found two to three blocks away in a brand new location. Streets are filled with debris and houses sit in the middle of the road. Near our house a woman stood in the street today with only one brown paper bag which she held tightly clutched to her body with tears streaming down her face. All around her was total destruction. She said, "this is all I could find, everything else has gone, my house, furniture and all my family mementos. This bag contains an African statue my father brought back from his travels and is the only thing I have left." Some streets have been washed out all together. Trash, docks, decks, bathtubs, refrigerators and all kinds of furniture and clothing lie about everywhere. I saw a garden snake and happily shared the news. The early day warnings of the dangers of a snake-filled island notwithstanding, it is the first one I have seen.

When the bridge opened for one-way traffic, the trailers that would become the new town hall were trucked in. Town

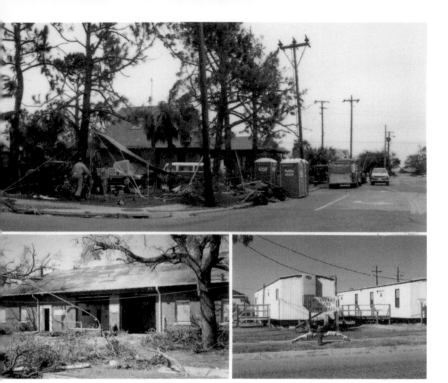

Three town halls. *Clockwise from lower left*: Boarded up Town Hall. *Courtesy National Park Service, Fort Sumter National Monument.* Medical offices of Dr. George Durst in use as a command center and the Sullivan's Island town hall relocated in trailers. *Both photos courtesy Sullivan's Island Fire Department.*

Council, which had been meeting informally in the Mt. Pleasant Presbyterian Church, occasionally by candlelight, had a regular session. Engineers contracted by the town began to survey each building. If a home was marked safe for occupancy, the residents could move back.

Friday, October 6.

Our dog is underweight, hyper, and uncomfortable, with a skin condition. He does not care to ride on boats, visit animal clinics, doctors or be away from home. The Ben Sawyer Bridge opened to one-way traffic today. I misread the start time and spent more than an hour at the head of the line of vehicles on the causeway talking with the state trooper who had been on duty here since the hurricane. I didn't mind the wait. It will get easier now.

Disaster researchers have long noted that the great strain placed on individuals may trigger any number of effects, positive or negative, and even precipitate a personal crisis.[80] This is because the same event impacts people in different ways and at different times. For some, the stress effects of the disaster may abate fairly quickly. Other victims may be more stressed long after the disaster, with stress actually increasing in the recovery period. Symptoms may peak seasonally; the beginning of the next hurricane season was tense for many. The intensity of one's stress might relate to the levels of personal losses and community destruction. Or it could be triggered by the combination of the hurricane and life events. Psychological reactions may linger, along with rising levels of depression and increased physical complaints. What happens in individual cases depends on demographics, social support systems, coping skills and a host of moderators, including whether a person feels some sense of control over the situation.

Researchers have noted that when disasters force people to relocate or otherwise impact their routine household activities, the result is a sharp rise in short-term stress and diagnosable post-traumatic stress disorders, with major differences by gender. Other

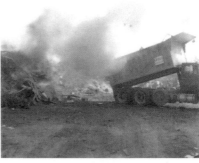

Debris being burned at a dump. The burning of debris on Sullivan's Island was discontinued when the air pollution began to pose a health hazard. *Courtesy Emergency Management Division, Charleston District, Army Corps of Engineers.*

factors that have been identified as affecting the impact of a disaster on individuals include the severity of the disaster, personal financial loss, age and marital status, the degree of available social support, personal mobility and income levels.

Once the immediate crisis has passed and the effects of the disaster event begin to subside, and as people work to get back to normal living patterns, they may exhibit symptoms of brownout. If prolonged, the brownout from exposure to too much work, frequent frustrations, emotional exhaustion and a rise in unhappy and negative feelings can turn into burnout. About this process we know relatively little. Experience with disaster also increases concern that it may happen again. Particularly in the case of natural disasters, reoccurrence concerns tend to intensify at the approach of the anniversary of the event. As the 1990 hurricane season approached, would Sullivan's Island residents be more apprehensive?

> *The smell floating over the entire island is one of stagnation and decay. Dead fish float along the shoreline for miles up and down the coast, the water is dark with pollution, only the bright*

131

sun sparkles like crystal above the stillness which hangs over the former picturesque tranquil, quaint island. I fear Sullivan's Island will never again hold its unique charm and quaintness. The sleepy little village atmosphere with only the lull of the lapping tide, clear skies, fluttering butterflies, and the easy going flight of the sea gulls and pelicans, with thousands of beautiful birds stopping to rest in the spring, fall and winter on their way to or from somewhere else has gone. There are no birds now and their missing songs create a strange forlorn feeling of unrest. Beautiful trees were snapped as if lightweight matchsticks, houses were twisted as if lightweight metal for molding, and stone walls, cinder blocks and brick walls were tossed about as if they were made of lightweight plastic.

Natural disasters are unplanned, unexpected occurrences. By comparison, other major difficult life events—a long-term illness, the death of a family member or close friend, or divorce—often are preceded by a period of growing awareness and preparation for the event's arrival. The absence of a time of advance preparation suggests that people will view the impact of a hurricane as being more stressful than other life events.

Three-quarters of the Sullivan's Island survey respondents said that Hugo had dramatically upset their lives. Nearly half (48 percent) said that the hurricane had been more stressful than the other life events they had experienced, including job change, loss of income and the death of a loved one, and a third (32 percent) rated the hurricane and their stressful life events as equivalent.

People were given a list of sixteen events that might have severely affected their lives. The list included both personal events such as a death in the family and hurricane-related events. More

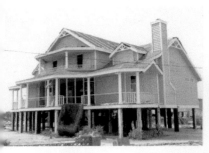

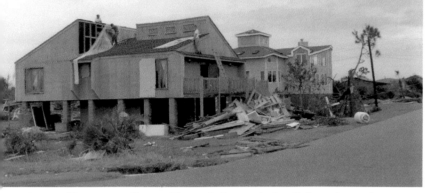

Damaged but structurally sound homes being patched until the major repairs could be made. *Courtesy of authors' personal collection.*

than half (54 percent) checked from three to six items and one person in eight (13 percent) checked seven items or more. The average was 3.8.

Compared to the impact of significant life events on their lives (on a scale where one is least and five is most), people rated Hugo 3.45. Household life event disruptions led the list, but people also compared Hugo strongly to significant work-related, personal and financial events they had experienced. On a four-point scale where four is high, people rated the degree the hurricane had upset their lives at 3.7 and rated their post-Hugo apprehension at 3.5.

133

Slightly more than half the people (51.5 percent) said they were still experiencing great stress. This group was predominately composed of male heads of household (72 percent) who owned property on Sullivan's Island, who had missed eight to ten days of work because of the overload from Hugo recovery tasks, many because they were widowed, divorced or separated and had no one else to pick up part of the load, and some had not been fully insured.

People were more stressed on returning to Sullivan's Island after the storm than they had been when they first heard the warning to evacuate and two-thirds said they were highly stressed their first time back. Worry about the dangers of living on a barrier island, which had been relatively low before Hugo, increased dramatically, and a majority of people (51.9 percent) were now more concerned that the island had only one bridge exit.

Entrepreneurs and small business owners in particular more than had their hands full dealing with the destruction to their establishments, rebuilding their businesses and juggling the needs of employees in addition to handling what had happened in their personal lives.

Factors that proved to be significantly related to burnout included the need to miss work to tend to hurricane-induced responsibilities, taking care of people and property in the aftermath of the storm, whether or not one benefited from the positive effect of being married (with some negative effects of extra stress in the case of dual career couples), the degree of damage a person suffered and how one fared in dealing with insurance companies.

The effect of damage and property loss on stress did not necessarily correspond to dollar amounts. How people perceived what had happened to their lives was more important, and perception, in turn, linked to how close one lived to the damage and

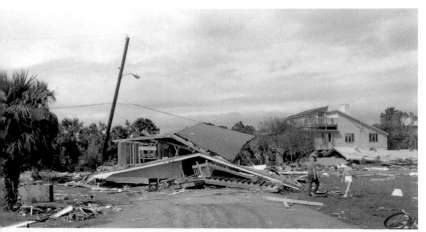

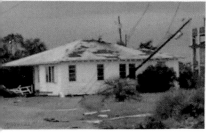

The new meaning of roadhouses. *Courtesy of authors' personal collection.*

debris during the recovery and rebuilding period. Those who lived closest to the damage after the storm tended to score higher on burnout, and those who saw their damage as severe and had continued to live in their homes had the highest scores. They also reported experiencing the largest number of storm-related life events, mostly household and work disruptions. In contrast, residents who were able to go somewhere else or had to because their homes were uninhabitable or destroyed and had most of their losses covered by insurance averaged lower burnout scores. Not surprisingly, a high percentage of the life events reported from this

group involved household repair difficulties. People who perceived damages to their homes to be minimal scored the lowest on the burnout scale, despite the fact that many of them had losses that were not covered by insurance.

Comments on the survey were consistent with the statistics. Some people wrote extensively. A number were grateful that someone was taking the time to ask about their problems. "Thanks so much for this questionnaire," several wrote. Others stopped the authors on the street to say thank you.

Written commentaries added to the robustness of the study. Hardly anyone found the hurricane inspirational. Testimony about renewed religious faith, succeeding through adversity or achieving character development from the hurricane experience numbered barely a dozen. Upbeat comments about "taking it" or "bouncing back" and descriptions of the hurricane as an adventure were equally rare. Far more common were the genuine feelings of irritation at those who seemed not to understand. "What I minded most," said one resident, "was the fact that four months later I was still patching things together and all around me were people who kept saying they had been barely scratched by the hurricane." "If I hear one more idiot say, 'God spared our home,' I will scream," said another. "Does that mean our house and our neighbor's were picked for destruction?" "What was worst," said a third, "was turning on the TV and listening to some self-appointed spokesman saying that this was making all of us stronger." A few did find the hurricane thrilling: "Easily one of the most dramatic and exciting things that ever happened to me. Winston Churchill remarked after the battle of Omdurman that it was exhilarating to have been shot at and missed. He was right."

Statements of desperation were few in number, but they were present. "I will never again feel as secure. I have lost faith in offi-

cials who think they know what is best for everyone. I can take care of myself better than anyone else can." "Separated from wife, business partnership broken up, debt rising." "Suicidal," wrote one. "Will life ever be the same?" several asked.

The Gatherer

The tall, stooped young man
came down the street
pulling behind him
a child's red wagon.

He wound his way
around fallen trees
and broken houses
until he reached my house
and asked,
"Do you have anything of mine
here in your yard?
Anything at all?
Some papers or pictures?
The hurricane took them all away."

He spoke the words wistfully,
like a child
looking for a lost toy.

I gave him what I had
that was not my own,
a packet of papers
with someone else's name.

He smiled,
carefully placing them
in his wagon.
On down the street he went,
collecting other treasures,
his tattered shirt
fluttering behind him
in the wind.

Irene Nuite Lofton

Some who felt they had been more fortunate than others felt guilty about it: "I suffered less than my neighbors. This made me want to help others. I didn't want to answer nothing when asked later, 'What did you do?'" Others learned lessons in a different school: "I am not so tolerant now. I'm too nice and this results in getting stepped on too often." Statements of apprehension, "I fear it will happen again," or incredulity, "initially unbelievable," and irritation, "inconvenient as hell," were common. Misery was described in a thesaurus of adjectives: "unsettled," "frustrating," "helpless." There were a number of variations on the theme that life after the hurricane seemed, as one resident put it, "less purposeful, less optimistic, and less satisfying."

Losses were not measured only in dollars: "It destroyed the large trees. Everything else can be replaced," wrote one resident. "I would rather have lost my house than my trees," another echoed. A young mother lamented, "I lost the first year of my baby's life dealing with this. I neglected pictures, keepsakes, and other family mementos." Would the stress abate? Wrote one person, "There is a tendency to deny how much one has

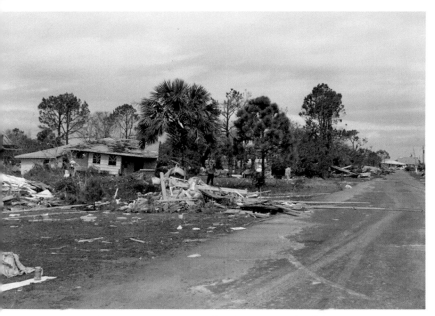

Scattered possessions. *Courtesy of authors' personal collection.*

suffered. The anger, frustration, grief, and sense of violation and of loss can be compared to the aftermath of an assault. The emotional stress seems to go on and on."

As the survey of people's circumstances and how they felt before and after Hurricane Hugo demonstrates, a natural disaster is a sharp blow. A large number of people exhibited a high level of brownout symptoms, indicating the onset of burnout. This may be attributed to adverse work stress reactions, the stress associated with the overwork involved in getting properties back to normal. Findings that many people felt Hurricane Hugo was more stressful than other life events they had experienced also suggests that not only can disaster victims be more stressed after the disaster than before but that stress may continue to escalate.

Island in the Storm

I Would Hold Back November

I am not ready
for the bustle of Christmas.
I long to have back
the days of fall.

I long to have back
our Indian summer
when sun lay golden
on the marsh
and the days were soft
with autumn.

A month of storm
has intervened
to interrupt
the gradual waning
into winter from fall.

I look at the calendar
and see winter days approach
and feel cold
creeping in at every crack.
But I still long for fall.

I would hold back the days of November.
I am not ready for December.

Irene Nuite Lofton

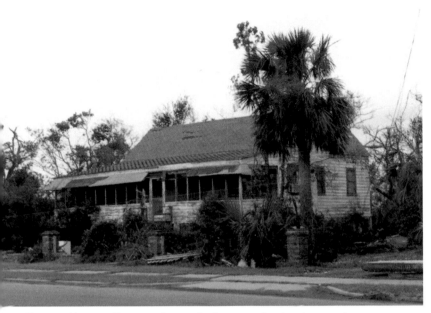

Damaged house adjacent to the marsh. *Courtesy of authors' personal collection.*

VII.
THE LESSONS

[During Hugo] *264,500 people were evacuated from their homes in eight counties.*

Executive Summary, Interagency Hazard Mitigation Team Report. (FEMA-843-DR-SC)

Fortunately, in this case, the response of state and local officials and of the general public of South Carolina was excellent. A massive evacuation of the coastal barrier islands was 90 percent complete several hours before landfall and this allowed a margin of safety which accommodated the increase in [Hurricane Hugo's] strength.

Miles Lawrence,
Preliminary Report Hurricane Hugo 10–22 September 1989
(National Hurricane Center, November 15, 1989)

The Lessons

HUGO AND FLOYD

The inland evacuation routes out of Charleston are defined by the Lowcountry geography. Until relatively recent geologic ages, the coastal plain of South Carolina was covered by ocean waters. The Sand Hills, approximately sixty miles inland from the shore, mark the former coastline. Just east of the Sand Hills is a long, sinuous swamp system that winds through the coastal plain paralleling the ocean for sixty-five miles. Just south of the Santee River basin, in the low-lying area known as Ferguson Swamp, the small, ill-defined channels that indicate the origins of the east and west branches of the Cooper River begin to twist their way seaward to join together thirty-two miles north of the Cooper River's outlet in Charleston Harbor. Farther south, on the eastern slopes of a Sand Hill ridge, the headwaters of the Ashley River are found. Both the Ashley and Cooper Rivers flow through great stretches of wooded swamplands and, nearer to the sea, low-lying marshes.[81]

A glance at the map reveals the limits this geology imposes on movement from the ocean to the interior. Highway US-17 follows the coastal plain between the swamp system and the ocean. SC-41 threads northwest along the swamp system's inland border. I-95 tracks north and south at the geologic shoreline. I-26, the main artery, and several paralleling highways, US-78 and US-178 to the south and US-176 to the north, head inland from the Charleston metropolitan area. From this main trunk, US-52 branches north along the higher ground in the Santee River Basin and SC-61 northwest. While it is possible today to build roads elsewhere, such as the I-526 connector that links Highway 17 to the north and south to bypass traffic around the Charleston peninsula, their construction requires crossing marshes and rivers and is more expensive. The highway system

created by the geography of land and water is fraught with natural choke points.

Though the particulars differ, local geography also defines the exits available to the concentrated coastal populations to the north (Georgetown-North Myrtle Beach) and to the south (Beaufort-Savannah).

The heavy traffic heading inland along I-26 at dawn on September 21, 1989, had moved at normal highway speeds, but broken-down cars, trucks and uncoupled boat trailers were already beginning to litter the roadside when, around 8:00 am, the exodus from Charleston County began merging with evacuees from outlying counties and the stream of evacuation traffic from the south moving northeast along the I-95 corridor. At the intersection of the two road systems, some fifty miles northeast of Charleston, traffic on both interstates slowed. On I-26, vehicles began crawling along at twenty-five miles per hour in a rolling gridlock that stretched from Goose Creek to Columbia. Worried that people would be trapped on the open highway, Governor Carol Campbell Jr. asked law enforcement agencies to begin planning to close the I-26 inbound lanes to Charleston and reverse them. But just before 2:00 p.m., when the operation was scheduled to begin, the jam cleared itself.[82] If it had not, it would have been a very close call. As a later Department of Highway study shows, with an existing plan, it takes about two hours to set out barrels and barricades and another two hours to flush the traffic out of the incoming lanes of the interstate. There was no practiced lane reversal plan in 1989, and stalled traffic could not have begun moving rapidly until well after 6:00 p.m. Stranded motorists might still have been on the highway when Hugo began to come ashore.

A potentially worst-case situation materialized in 1999 when six-hundred-mile wide Hurricane Floyd, a near Category 5 storm

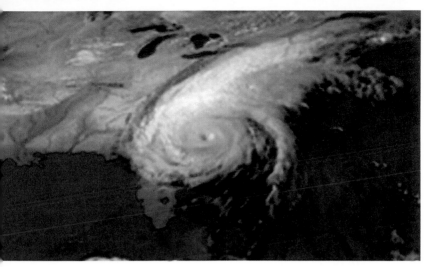

Hurricane Floyd at 8:15 p.m. on September 15, 1999. *Courtesy NOAA GOES satellite, image produced by Hal Pierce, Laboratory for Atmospheres, NASA Goddard Space Flight Center.*

when it approached the Bahamas and a borderline Category 4 when it seemed to take aim at South Florida, was turned northward by an approaching front to threaten the entire southeastern coast of the United States. Unlike Hugo, which had maintained a relatively steady northwest track after crossing Puerto Rico, Floyd went westward toward the Florida coast before turning. The storm's track triggered the most massive peacetime evacuation in the United States. An estimated 2.6 million to 3.3 million people were on the move. The swell of evacuees from Florida numbered perhaps as many as two million, and hundreds of thousands of them poured into Georgia to collide with evacuees heading west from Savannah.[83]

Along the South Carolina coast, people began to pay close attention to their most frequently consulted source of weather information, the Weather Channel, to which nearly 90 percent of the

residents in coastal South Carolina have access. Local television is second, and nearly half of the population leaves one channel or the other on all day during the two- to three-day approach of the major hurricane. At 7:00 a.m. on Tuesday, September 14, South Carolina Governor Jim Hodges called for a voluntary evacuation of the coastal areas. At noon, he issued a mandatory evacuation order. The close spacing meant that coastal residents left in two large surges, the first between 9:00 a.m. and 3:00 p.m. on Tuesday and the second during the daylight hours of Wednesday, September 15, when forecasts predicted Floyd would most likely come ashore that night somewhere near Charleston. In all, nearly two-thirds of the people in coastal areas would evacuate, half of them leaving in one six-hour period.[84]

Congested I-95 in the center of the state was already approaching gridlock on September 15 when the 360,000 to 410,000 evacuees exiting the Charleston metropolitan area—one and a half times as many people as evacuated eight South Carolina counties during Hugo—started clogging the outbound lanes of I-26. Cars on the interstates backed up for hundreds of miles, ran out of gas and broke down. The decision to reverse the inbound lanes of I-26, delayed unnecessarily by perhaps as many as eight hours, took time to execute. The normally two-hour drive from Charleston to Columbia took up to ten hours. Some motorists were on the highways considerably longer as they made their way to destinations as far as Tennessee.[85]

There were a number of reasons why the I-26 gridlock developed. State level evacuation planning for Florida, Georgia, South Carolina and North Carolina had been carried out individually, and during Floyd the states were largely acting in isolation. South Carolina had no practiced, formal lane reversal plan for I-26. Because of separate field radio systems, state agency personnel were unable to directly communicate within and across state agencies.[86]

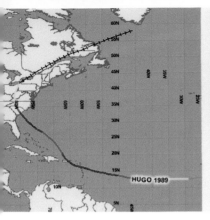

Tracks of Hurricane Hugo, *left* (*Courtesy NOAA*) and Hurricane Floyd, *right* (*Courtesy National Weather Service*).

But it was not just these things or the way Hurricane Floyd's track threatened the eastern seaboard that caused the gridlock. Between Hugo and Floyd, the population of the Berkeley-Charleston-Dorchester region had increased by 42,158 (8.32 percent). More than half of that growth took place in Berkeley and Dorchester Counties, 27,228 people (12.85 percent). To save possessions, as many as one-quarter of all households evacuating during Hurricane Floyd took one or more vehicles. During Floyd, much heavier traffic was moving on to I-26 ahead of the evacuees from the coastal portion of Charleston County.[87]

Normal daily traffic between Charleston and Columbia, which can seem bumper-to-bumper, moves at a high-speed rate of 2,000 to 3,000 vehicles per lane per hour. During Floyd, the road was so crowded that traffic movement was cut nearly in half, to between 1,500 to 1,600 vehicles per lane per hour because the number of people who can occupy a roadway at one time is finite, and as that limit is approached, everything must slow down.[88] South Carolina's rapidly increasing coastal population had reached the point where, when coupled with a coast-hugging major hurricane that causes

ʰuge evacuation from Florida and Georgia, the result will be a major highway gridlock that originates in the interior of the state and rolls back to the coast.

The continuing population growth contains another implication. Between 2000 and 2004, population in the tri-county area grew by 34,401 (6.27 percent), again with slightly more than half the increase in Berkeley and Dorchester Counties, 17,608 people (7.37 percent).[89] The effects are seen in the everyday commuter traffic. Near the Charleston peninsula, traffic exiting both north and south along US-17 at rush hour moves at a stop-and-go twenty-five miles per hour. Vehicles heading up I-26 average twenty-two to twenty-six miles per hour. Traffic on I-526 moves more rapidly until that exiting on to I-26 crowds the highway. Then speeds drop as low as twenty-two miles per hour. Commuter driving times on the other major arteries leading out are in the same range: thirty-three miles per hour on SC-61, twenty-eight miles per hour on US-52 and twenty-three miles per hour on SC-41 leaving US-17.[90]

These figures are for a workday free of accidents and breakdowns. In the face of an oncoming hurricane, the total number of vehicles that now clog the roads during the rush hours can be expected to increase by the many drivers who have the daily choice of traveling at other times, the large numbers of people who usually stay at home and growing number of households that will evacuate in two or more vehicles.[91]

To put it simply, the likelihood of a Floyd-like gridlock developing at the *very beginning* of a mass Lowcountry evacuation if the I-26 incoming lanes are not immediately reversed has risen dramatically.

As for traffic into the interior of the state, a mathematical model developed after Hurricane Floyd suggests it could take up to forty hours to evacuate half a million people from the coasts by interstate if the lanes are not reversed immediately, a full twenty-four hours if they are.[92]

What all this means is that political leaders can expect to be faced with a situation where they will have to recommend or order an evacuation of threatened areas well in advance of their knowing exactly where a hurricane will come ashore. They can also expect, as was the case for Charleston during Hurricane Floyd, that, on occasion, the hurricane will move on, perhaps leaving them with a disgruntled public. "That is a reality," says Charleston Mayor Joe Riley,

> *but the dangers of not ordering a necessary evacuation can be so great that any possible political consequences should not be considered. Leaders will have to do their best; listen to the experts, evaluate the evidence and act in ways that, when looking back, make it clear that based on what was available at the time, their decision was the most prudent and logical choice one could make.*

"Joe Riley is exactly right," says County Council member Ed Fava, "and I respect him tremendously. But we all know that many politicians look only at how their decisions will affect their prospects in the next election, and not everyone holding public office acts wisely."[93]

ADVICE FROM THE HUGO EXPERIENCE

People who experienced Hurricane Hugo say the same thing: "Evacuate, and get out early." Given that up to half a million people may be following the same advice, advance preparation is absolutely necessary.

Advice on how to prepare is readily available. The South Carolina Emergency Management Division's *Hurricane Guide* is

a comprehensive source for preparation tips, evacuation routes, emergency radio frequencies, telephone numbers, websites and more. Anyone living on a barrier island or in an area where post-storm access may be controlled should obtain the proper identification, including automobile stickers. The disaster plans for most of these municipalities also give additional information on local emergency contact numbers and locations where information can be obtained, including plans for getting people back to their homes. Local media hurricane tips and tracking maps are also available at many retail locations.

Be prepared to exist three to five days without assistance. That means you need a place to stay, relatives or friends inland or commercial accommodations, which will fill up quickly. A list of evacuation shelters may be found, among other places, in the SCEMD *Hurricane Guide*. To know how you are going to get to your destination, map out possible evacuation routes and even drive them a short distance in advance to get a feel for road conditions.

Plan to leave home *before* an emergency is declared because traffic on all evacuation routes will be extremely heavy afterward. Here's how. A hurricane watch means that hurricane conditions are possible within thirty-six hours. A hurricane warning means that hurricane conditions are expected in a specified area, usually within twenty-four hours. There will be less traffic in the twelve-hour window between a watch and a warning. Does this mean you are likely to evacuate in a false alarm? Yes, but the risks of staying put at the wrong time—especially the dangers of not being able to leave or of being stranded in a highway traffic jam—are too great to ignore.

Keep informed. There will be extensive radio and television coverage of the potential hurricane tracks as a storm approaches. The most informative and least hyperventilated source of information, updated frequently, will be the National Hurricane Center, which can be accessed online at http://www.nhc.noaa.gov/.

The Lessons

Where you live is probably in a flood plain, meaning the land can be covered in a storm surge. Almost everything east of Highway-17 is liable to flooding from the tidal surge in a Category 1 hurricane, most of the Charleston metropolitan area in a Category 2 and nearly everything else in a Category 3 or higher. People located in a flood zone (where the special building codes apply) and liable to flooding (an A zone) or flooding plus wave action (V zone) are the most vulnerable.

Lessons from the Experiences of People on the Barrier Islands During Hugo

Planning ahead to protect yourself and your property can take time, but it will prove invaluable if a major hurricane hits because then your life will change suddenly and dramatically. The planning will also lessen the inevitable post-storm stress.

Check your insurance policies. Among the hardest hit financially were people who found out too late that their insurance coverage was not what they thought it was. Make sure your fire and wind (comprehensive) policy covers what it would cost to rebuild in today's market. If you don't have the separate flood policies for property and contents and live in the flood plain, purchase them even though your property has never been under water. Category 4 Hugo did not come in at high tide.

Store a safe copy of all your important financial information for quick access after a storm. This is much easier to do today than it was in 1989. The list should include account numbers, credit and other cards, customer service telephone numbers and online passwords. Flash drives that enable you to copy and encrypt your files and view your complete desktop from another computer and then leave no traces when you are finished are on the market.

Prepare a complete, dated picture inventory of all your property that includes documentation of the most costly items. Store at least one copy in a safe deposit box or with a family member or friend who lives somewhere else. If you have the blueprints for your residence, do the same thing with them. Insurance companies are not likely to argue when given documentation of loss.

After Hugo, many on the barrier islands considered the destruction of family photographs, documents and mementos their greatest loss. Today's computer technology makes it easier to back up and securely store these items. Consider putting valuable family documents and photographs in digital form and store them along with your important financial and other information.

Odds are that after the storm you will be expected to carry on with your job as if nothing had happened at the same time you are trying to put your life back together. Small business owners and organizational key people in particular will confront this problem. If you own a business, have important professional papers, or play a critical organizational role, be sure all irreplaceable records are backed up somewhere on a computer or storage disk outside this danger zone. These spaces are now provided online in other locations.

Think carefully before you get rid of a landline telephone. After Hugo, they continued to work when the other public utilities were out, even on the barrier islands. The 2005 Gulf Coast hurricanes knocked out the cell phone towers. A small generator and a battery-powered radio for news will be helpful if you are able to access your residence before electric power is restored.

In addition to keeping your prescriptions refilled, be sure you have their full and complete names along with your medical insurance information. Your doctor and drugstore may not be in operation when you return.

If you must be away on business during the hurricane season, have a prearranged pickup for your pets. During Hugo, a dog from

the Isle of Palms successfully paddled atop the storm surge to make it safely to Mt. Pleasant, where he was cared for. Not all pets will be that resourceful or fortunate.

In a mandatory evacuation, you will be asked to cut off power to your house at the main breaker. Before you do, remove frozen and perishable items from your refrigerator and freezer. If you don't, with the power out, the food will spoil and your appliances will be completely ruined.

Appendix 1
Study Methodology

This is the seventh survey I can remember. I've thrown the others out. I don't want to be someone's laboratory rat. I've been through enough and it continues. I only answered this because you were fellow residents. I would like to be more helpful but I am drained to the limit.

Sullivan's Island resident

Research Methodology

As any number of research studies have pointed out, complex hazard mitigation and disaster studies designed to assess attitudes of large groups are difficult to plan and implement. Consequently, there are a number of unfilled gaps in field studies of hazard impacts and recovery from disasters because of such practical prob-

lems as gaining access to victims, securing their cooperation and dealing with problems of population dislocation.[94]

A primary methodological constraint has to do with the length of survey instruments. To be useful, a number of questions need to be asked. But traditionally, people will not take time to fill out a long questionnaire. One study offered a solution.[95]

The survey, conducted in June 1990, was timed to coincide with the beginning of the new hurricane season. The anniversary could be expected to heighten attention. Few residential structures on Sullivan's Island had been completely repaired or replaced at the time and, according to town officials, fewer than 40 percent of island residents were living in their homes. Personal interviews were conducted over the next two years and again recently.

Prior to the storm, the Sullivan's Island Post Office delivered to some 450 rural route addresses and 650 post office boxes. In June 1990, deliveries were going to 350 addresses and 500 boxes. To obtain the broadest island coverage of the impact of the hurricane experience, supplementary mailing lists were constructed from the Sullivan's Island Town Council water-meter accounts and Charleston County Tax Maps. Questionnaires were mailed first class on the first day of the new hurricane season. After a two-week period, follow up questionnaires were posted to the non-respondents. A post-mailing inventory determined that of the 950 questionnaires mailed, only 876 went to valid addresses. Of this total, 242 questionnaires were unusable because they had been returned as undeliverable due to missing forwarding addresses or mail boxes, because the address represented multiple property owners or because a resident had both a street address and a post office box. Thus the operable mailing list included 634 addresses, from which we received 274 completed forms, a response rate of 43.2 percent.

Appendix 1

Comparison of survey results with public records showed no statistically significant differences between the pre-storm population of Sullivan's Island and post-hurricane respondents for demographics such as age, sex, race, marital status and number of people in the household. Comparison also showed no statistically significant differences between averages of the assessed value of property reported by respondent owners and county tax map data. Nor were there any statistically significant differences between the various levels of property damage reported by respondents in categories that lent them to comparison with damage and recovery assessment completed a year after the storm. The absence of differences suggests the questionnaire sample accurately portrays the Sullivan's Island population, with one possible exception. Though there is no way to determine exactly the number of renters residing on the island just prior to the hurricane, because not all rental units were recorded on town records, the fact that the questionnaire respondents were mainly island property owners (N=253, 92.3 percent), year-round residents (N=116, 42.3 percent) or owners of family vacation or summer homes (N=65, 23.7 percent) or rental property (N=33, 12.0 percent) suggests that the pre-storm rental population, which was dispersed after the storm, may be slightly underrepresented in our study. However, given that more than 40 percent of all the island respondents returned a questionnaire under conditions where all residents had severely damaged property and many people could not get back to live in their properties for nine months or longer after the storm, we believe the sample to be representative.

The thirteen-page survey instrument was carefully designed, developed and administered to protect the anonymity of individual responses. This was especially important as sections of the questionnaire addressed issues about the amount of prop-

erty damage, financial loss, insurance coverage, stress and other highly sensitive items. In a cover letter to each respondent, the authors identified themselves as island residents conducting an academic study supported by a Citadel Development Foundation Research Grant and in full compliance with the provisions of Public Law 93-579, the Privacy Act of 1974, which requires that all individuals be informed of the purposes and uses to be made of the information which is solicited. Recipients were assured confidentiality of individual responses. The cover letter informed readers that the questionnaire would require approximately thirty minutes of their time to complete. Sections of the questionnaire covered demographics, perceptions regarding town government action following the hurricane, stress effects, property loss, insurance coverage, the personal impact of the storm and experiences with insurance adjusters and building contractors. Open-ended questions asked for first-hand resident experiences and recommendations for pre-storm preparations. A brief outline of the instruments used to collect data in each of the major areas is provided below.

DEMOGRAPHICS

The first section of the questionnaire, Personal Data, requested information on the type of residency the respondent had on the island (i.e., property owner, renter, primary residence, owner of rental property, vacation or second home or business property owner) and length of that particular status on the island. In the section for head of household, many of the residents identified themselves by name even though this was specifically not requested in addition to providing their age, sex, race, marital status, whether they were part of a dual career couple and the total number of members in their families at the time of the

storm. This section of the questionnaire also requested information on whether respondents remained in their properties while repairs were in process or how long they had been off the island while repairs were being made. If they evacuated the island as the storm approached (an overwhelming majority of people did), we requested detailed information.

GOVERNMENT AND THE EMERGENCY DECREES[96]

Post-hurricane Sullivan's Island government actions were assessed with five-point Likert type scales (1, disagree completely to 5, agree completely, by asking five questions (pre) to measure the feelings at the time of the decisions and five questions (post) to measure the present reaction to government decisions that kept islanders from returning to their properties immediately after the storm). Measures included an analysis of demographic data breakouts by dollar values of damage to property and the indication of apprehension at the approach of a new hurricane season (1, none; 2, lower than at the time of Hugo; 3, the same as nine months ago; 4, higher than before Hugo), as related to the implementation of "martial law." Reactions to "martial law" and town government decisions were measured on five point Likert type scales (1, disagree completely to 5, agree completely) for three sets of items: (1) degree of interference with personal rights; (2) delay in repairing property added to the damage; and (3) impact on self governance (Alpha=.92). A similar scale was used to measure responses to a statement that martial law was a necessary measure (1, disagree completely to 5, agree completely). Other questions also asked for the survey code that had been assigned by engineers who rated post-storm property damage and the flood map zone in which the residency or property was located. Questions to address these matters were

included in several sections, the most comprehensive being the section labeled "Martial Law" on Sullivan's Island. Because it was still commonly believed, even though it had never been declared, the term "martial law" was used in the survey rather than the accurate description of the actions taken under the emergency decrees.

STRESS, BROWNOUT AND BURNOUT EFFECTS[97]

Stress impact of the hurricane was measured in several ways. The major topics included the Personal Safety Impact, a Brownout to Burnout Inventory, Life Events and Generic Areas. Safety Impact was measured by eleven questions addressing the degree of concern felt from the impact of the natural disaster. Each question was accompanied by five-point Likert-type scales with anchors extremely (1) to barely (5). Questions included areas of concern arising from initial evacuation warnings to the impossibility of returning to the island because the bridge was down following the disaster.

A twenty-item Brownout to Burnout inventory was selected and modified for this study with a Likert-type scale because in interviews with hurricane victims it appeared to bear a close resemblance to the conditions islanders faced after the storm.[98]

The inventory examined underlying dimensions of emotional exhaustion, personal accomplishment, depersonalization and reduced personal accomplishment or social jarring as well as stressful work-related events (reliability= .84 with validity established for a number of job dimensions). The questionnaire instructions requested responses to the stem statement "Since Hugo, I have experienced the following effects to the degree circled below: Extremely (1); Moderately (3) to Barely (5) or No Change (0)."

Appendix 1

A sixteen-item version of the Schedule of Recent Experience (SRE), labeled the Social Readjustment Rating Scale (SRRS), was modified to assess the impact of the hurricane within the framework of other life events.[99] The relationship was examined by using a scale that was especially designed to capture such stressful post-disaster events as household disruption (defined as problems in rebuilding, contractor misrepresentation, dealing with insurance companies and building contractors, increased demands on time, increased debt and lack of income) as compared with family-life events people may have experienced, such as conflict (separation and or divorce) or bereavement (death of loved one or close friend) and work-related life events. An open-ended blank provided each respondent the opportunity to record other events not included on the list.

A number of generic questions were used to assess the overall stress level. At the completion of this measure, each respondent assessed the degree that Hugo was a stressor relative to other life experiences. The final open-ended section of the questionnaire addressed the general impact of Hurricane Hugo on the lives of island residents and requested information to alleviate future hurricane problems. To view links between work and home, respondents were requested to list absences from work prior to Hugo and post-Hugo on an annual basis, along with the primary reasons for missing work.

INSTRUMENTS TO MEASURE INSURANCE COMPANY RESPONSIVENESS AND TREATMENT[100]

Because the storm had affected nearly everyone who lived on the island or had property, people were asked about the storm's impact in terms of one's personal safety, whether or not one had insurance coverage, the name(s) of the insurance company(ies),

the type of coverage (homeowner or wind insurance on structure; homeowner or wind insurance on contents; flood insurance on structure; flood insurance on contents; comprehensive insurance; earthquake insurance, etc.) and the dollar value of any property damage. Questions addressed the personal safety impact of the storm, insurance company coverage pre- and post-storm, property and contents coverage and damage, perceptions of insurance company effectiveness, the amounts and type of property insured, uninsured losses, the length of time and reasons for being out of residence after the storm and the respondents' perceptions of insurance company management style and satisfaction with settlements. Due to a relative absence of studies on the insurance impact on hurricane victims, it was necessary to develop a number of measures. Reliability was established for the various scales with the Cronbach Alpha split-half coefficient procedure.

To examine insurance company effectiveness, the study adopted an existing model of business service that suggests that policyholders might evaluate the performance of their insurance company along a scale ranging from extremely disappointing to top performance.[101]

Four sets of questions were used to examine damages and related perceptions of insurance companies and level of coverage. For those who had more than one insurance company, respondents were asked to rate each company on separate sets of scales in each of the areas.

To gauge pre- and post-storm insurance coverage, a twenty-item checklist requested information on the respondents' homeowners or wind insurance coverage on structure and contents, flood insurance on structure and contents and comprehensive and earthquake coverage by insurance company. In cases where insurance coverage did not pay for the damages, respondents were asked to

list the reasons. Policyholders were also asked about their policy coverage prior to the disaster. A second set of questions asked for details of any changes in policy coverage since the hurricane. Stem questions were included to assess the level of knowledge and coverage pre- and post-storm. Coverage Information, the variable compiled from the stem questions, was operationalized by policyholder discussions with insurance agents prior to the storm and awareness of the cost and coverage pre- and post-Hugo (1, Yes or O, No). A follow-up stem question asked for reasons for insufficient insurance coverage. Items included such statements as "Not required to purchase flood insurance when I purchased the property" or "I had the impression my homeowners or wind policy covered flood damage." A final question asked affected respondents to give the single most important reason they did not have flood insurance. A yes/no question inquired about change in insurance coverage for flood damage and wind damage pre- and post-hurricane. The index of change for each type of coverage was measured on a percentage point scale (1, 10–20 percent: 2, 30–40 percent: 3, 50–60 percent: 4, 60–70 percent: 5, 80–90 percent; 6, 100 percent).

Each respondent was asked to assess the dollar damage to property and the insurance coverage settlement. Separate questions assessed the dollar values of the degree of damage to property, the name of one's insurance company and the type of coverage (homeowner or wind insurance on structure; homeowner or wind insurance on contents; flood insurance on structure; flood insurance on contents; comprehensive insurance; and earthquake insurance).

A separate set of questions dealt with insurance company responsiveness, from the first post-storm contact onward, as well as the respondent's overall satisfaction with the final settlement. Insurance company responsiveness was measured by the number of weeks

before the initial contact. Within one week was considered to be a very fast response (1); one to two weeks, fairly fast (2); two to three weeks average (3); three to four weeks, slow (4); and more than a month, extremely slow (5). The time it took to get together with an insurance adjuster was measured on the same type of scale as the initial response time. The questionnaire asked for the number of adjusters one had to deal with to settle a claim, (count of 1 to 6) and the month of the settlement, ranging from (1) October 1989, to (8) May 1990, to (10), not yet settled. Respondents were asked to circle the level of satisfaction with the settlement of their claims on a five-point Likert type scale (5, extremely satisfied; 4, satisfied, no major problems; 3, some problems but it worked out; 2, not all problems resolved satisfactorily; 1, not satisfied).

Additional questions measured insurance company management style and effectiveness with an eighteen-item instrument that included perceptions of effectiveness of companies in establishing disaster offices to facilitate claims processing; the company representatives' level of training, knowledge, professionalism and expertise; any experiences with unnecessary bureaucracy or red tape delays; and a measure of comparable equity in insurance company treatment. Responses were provided on five-point Likert-type scales, with higher values representing more positive reactions (1, disagree completely to 5, agree completely within an established alpha= .90). Specific measures included services provided to policyholders such as hotlines, contact time, disaster office location, adjuster replacement and notification.

Questions also asked for a comparative analysis of the treatment one received with that perceived to be received by friends and acquaintances from other insurance companies. Open-ended questions were included to assess whether or not a policyholder had to take action to get an insurance company to respond and the type of action taken, such as seeking legal assistance, professional engi-

neering assistance or other measures to bring the claim to settlement. An identical second scale (alpha=.87) was completed by the seventy-four respondents who had more than one insurance company.

The data analytical methods employed in the study included descriptive and frequency procedures, the analysis of covariance (ANCOVA), step-wise linear regression, correlation analysis, ANOVA analyses and Nonparametric Wilcoxon Matched Pairs Signed Rank Tests.

Preliminary findings from the study were published between 1992 and 1994. Several are cited in the notes, as are the more detailed studies published subsequently.

APPENDIX 2
TABLES

TABLE 3-1
RESPONSES BY PERCENTAGE TO "MARTIAL LAW"

	Necessary and proper	Interfered with rights	Felt frustrated or angry	Had feelings of resentment
Completely Disagree	27.3	23.0	23.0	26.9
Disagree	5.6	4.1	4.9	4.2
Neutral/No Opinion	12.4	17.7	20.9	22.7
Agree	9.2	7.4	7.8	8.4
Completely Agree	45.4	47.7	43.4	37.8

TABLE 3-2
PERCENTAGES OF RESPONDENTS IN EACH GROUPING

	Entire Sample	Property Owner	Resident Owner
Martial law interfered with my right to return to examine damage	55.1	49.0	59.4
I felt frustrated or angry at being kept from making repairs	51.2	50.7	58.8
At the time I resented the absence of citizen voice in town decisions	46.2	45.6	52.0
At the time I felt that martial law was necessary	54.6	55.3	6.0
At the time I believed people should have been allowed back immediately	32.9	32.5	44.1

Appendix 2

TABLE 5-1
PERCEPTION OF DAMAGE TO HOME

Degree of Damage	Percent of Respondents
Minimal	9.6
Some Damage	29.5
Severe but Habitable	15.9
Severe and Uninhabitable	40.2
Destroyed by Hugo	4.9

TABLE 5-2
DOLLAR VALUE OF DAMAGE TO HOME

Property Damage and Loss	Percent of Respondents
None	1.8
Under $10,000	9.1
$10,001-$40,000	29.6
$40,001-$70,000	19.7
Over $70,000	27.1
Unknown/No Response	12.7

TABLE 5-3
SELF-REPORTED DAMAGE OR LOSS OF PERSONAL POSSESSIONS

Damage and Loss	Percent of Respondents
None	8.0
Under $10,000	39.4
$10,001 or more	39.3
Unknown/No Response	13.3

TABLE 5-4
SELF-REPORTED UNINSURED LOSS

Uninsured Loss	Percent of Respondents
None	16.4
Under $10,000	29.9
$10,001–$20,000	16.8
Over $20,001	26.7
Unknown/No Response	10.2

Sources

ABBREVIATIONS

CCEPD—Charleston County Emergency Preparedness Division
CDCOE—Charleston District, U.S. Army Corps of Engineers
DINPS—Department of the Interior, National Park Service
EMDCDCOE—Emergency Management Division, Charleston
 District, U.S. Army Corps of Engineers
FEMA—Federal Emergency Management Agency
FSNM—Fort Sumter National Monument, National Park Service,
 Department of the Interior
NHC—National Hurricane Center
NOAA—National Oceanographic and Atmospheric
 Administration
SCARNG—South Carolina Army National Guard
SCHA—South Carolina Historical Association
SI—Town of Sullivan's Island
USACOE—U.S. Army Corps of Engineers

CHARLESTON PAPERS

News and Courier
Post and Courier
Post-Courier
Post-Courier/Evening Post

NOTES

Acknowledgements

1. Irene Nuite Lofton, *The Broken Bridge, The Year After Hugo, 10ᵗʰ Anniversary Edition* (Charleston: privately printed, 1990, 2000).

Chapter 1

2. Edgar Allen Poe, illustrated by Elizabeth O'Neill Verner, *The Gold Bug, Sullivan's Island Edition* (Charleston: Tradd Street Press, 1969), 28.

3. Jamie W. Moore, *The Lowcountry Engineers, Military Missions and Economic Development in the Charleston District, U.S. Army Corps of Engineers* (Charleston: Charleston District, U.S. Army Corps of Engineers, 1981), 7; Walter J. Fraser Jr., *Charleston! Charleston! The History of a Southern City* (Columbia: University of South Carolina Press, 1989), 1–2; Suzannah Smith Miles, *Writings of the Islands: Sullivan's Island and Isle of Palms* (Charleston: The History Press, 2004), 15–16, 19–24.

4. Miles, *Writings of the Islands*, 149–50, 29–31, 34–35; Fraser,

Charleston! Charleston!, 33–37, 78; Peter H. Wood, *The Black Majority—Negroes in Colonial South Carolina from 1670 through the Stono Rebellion* (New York: Norton, 1996), xiv.

5. Edwin C. Bearss, *The First Two Fort Moultries: A Structural History, Fort Sumter National Monument* (Washington: National Technical Information Service, 1968), 8–9. Jim Stokeley, *Fort Moultrie, Constant Defender* (Washington: Department of the Interior, National Park Service Handbook 136), 15–27, is an excellent summary of the action.

6. G.R. Barnes and J.H. Owen, eds., *The Private Papers of John, Earl of Sandwich, First Lord of the Admiralty, 1771–1782* Vol. 1, August 1770–March 1778 (London: Naval Records Society, 1932), 129–43. Neither General Clinton nor Commodore Parker was punished for his conduct.

7. Gadsden Cultural Center, *Images of America: Sullivan's Island* (Charleston: Arcadia Publishing, 2005), 7–8; Jason Annan and Pamela Gabriel, *The Great Cooper River Bridge* (Columbia: University of South Carolina Press, 2002), 16.

8. Jamie W. Moore, *The Fortifications Board 1816–1828 and the Definition of National Security* (Charleston: The Citadel Monograph Series Number XVI, 1981); Jamie W. Moore, "The Bernard Board and Coastal Defense Evolution," *Journal of the Council on America's Military Past* XIV, no. 2 (June 1986): 3–13.

9. Frank Durham, "Poe on Sullivan's Island," introduction to *The Gold Bug, Sullivan's Island Edition*, 3–4.

10. Miles, *Writings of the Islands*, 54–62.

11. Moore, *Lowcountry Engineers*, 27–30. On Civil War strategy and tactics see the sources cited, 121–22.

12. Ibid., 18–21, 31–39, 122–23.

13. Jamie W. Moore, "National Security in the American Army's Definition of Mission, 1865–1914," *Military Affairs* XLVI, no. 3 (October 1982): 127–31.

14. Moore, *Lowcountry Engineers*, 49–57.

15. Miles, *Writings of the Islands*, 95–98, 119–22; Annan and Gabriel, *The Great Cooper River Bridge*, 4–16.

16. Jamie W. Moore and Dorothy P. Moore, "The Corps of Engineers and Beach Erosion Control 1930–1982," *Shore and Beach* 51, no. 1 (January 1983): 13–17; Wendy Nilsen Pollitzer, *Images of America: Isle of Palms* (Charleston: Arcadia Publishing, 2005), 7, 10, 13, 15.

17. *Evening Post*, November 1, 1937; J.V. Nielsen Jr., "Trip to Beach was Voyage Back in the good Old Days," *News and Courier*, May 15, 1960; Pollitzer, *Isle of Palms*, 7, 23. The incorporators also included J S. Lawrence, Philip H. Gasden and W.W. Lawton.

18. Jamie W. Moore, "The Lowcountry in Economic Transition: Charleston since 1865," *South Carolina Historical Magazine* 80, no. 2 (April 1979): 156–71.

19. Miles, *Writings of the Islands*, 127–30, 66–71.

20. *Moultrie News*, November 9, 2005.

21. *News and Courier*, September 21, 1982.

22. The advisory referendum was held on September 19 as Hurricane Hugo approached. Turnout was heavy. The proposal to build the bridge carried by the bare majority of forty-five votes. Susan Taylor Martin, "In the eye of the hurricane," *St. Petersburg Times*, June 12, 1990, http://www2.sptimes.com/weather/HG.6.html. On October 4, 1989, less than two weeks after Hugo struck, the Isle of Palms Town Council gave its approval to build the connector. The bridge opened in 1993. *News and Courier*, October 5, 1989.

Chapter II

23. Coordinated Universal time (UTC) is the atomic time standard which tracks universal time and is the basis for legal civil time. World time zones are expressed as positive or negative offsets from

UTC. This is also referred to as Zulu time (Z) or Greenwich Mean Time (GMT). http://en.wikipedia.org/wiki/UTC.

24. NOAA. http://www.spc.noaa.gov/faq/tornado/beaufort.html.

25. NHC. http://www.nhc.noaa.gov/aboutsshs.shtml.

26. Philip J. Klotzbach and William M. Gray, "Extended Range Forecast of Atlantic Seasonal Hurricane Activity and U.S. Landfall Strike Probability for 2006," Department of Atmospheric Science, Colorado State University, hurricane.atmos.colostate.edu/Forecasts. Between 1851 and 2004, a total of thirty-one tropical cyclones struck the South Carolina coast, six of them major (Category 3 or above). NHC. http://www.nhc.noaa.gov/paststate.shtml.

27. Fraser, *Charleston! Charleston!*, 11, 16, 31, 44, 83–85, 189, 193, 233, 293–94, 314–15, 326–27, 352, 387, 411–12, 432; Mary Moore Jacoby and John W. Meffert, *Charleston: An Album from the Collection of the Charleston Museum* (Dover: Arcadia Publishing, 1997), 100; Stokeley, *Fort Moultrie, Constant Defender*, 30; Miles, *Writings of the Islands*, 131–46; NOAA. hurricane.csc.noaa.gov/hurricanes/viewer.html.

28. Joyce V. Coakley, *Sweetgrass Baskets and the Gullah Tradition* (Charleston: Arcadia Publishing, 2006), 12–13.

29. Miles Lawrence, "Preliminary Report Hurricane Hugo 10–22 September 1989," NHC, November 15, 1989; Bo Peterson, "'Miss Piggy' tough enough to fly into teeth of storm," *Post and Courier*, May 5, 2005; NOAA. http://www.aoml.noaa.gov/hrd/Storm_pages/hugo1989/19890915H1.html.

30. Lawrence, "Preliminary Report Hurricane Hugo." The warning time at Guadeloupe was thirty hours, for St. Croix thirty-five hours. Since Hugo, hurricane track forecasting has become even more accurate. By 2004, the five-day track-forecasting margin of error of one hundred statute miles equaled the late 1980s three-day margin and three-day forecasting had become as accurate as the late 1980s two-day prediction. http://www.nhc.noaa.gov/verification/verify5.shtml?

31. Lynne Langley, "Timber Industry Faces Decades of Recovery," *Post and Courier*, September 23, 1990; News and Courier/Evening Post, *And HUGO was his name: Hurricane Hugo, A Diary of Destruction* (Sun City West, AZ: C.F. Boone Publishing, 1989), 30.

32. NHC. http://www.nhc.noaa.gov/HAW2/english/history.shtml#hugo.

33. Berkeley-Charleston-Dorchester Council of Governments' Management and Planning Systems Program, "Sullivan's Island—Hurricane Hugo: One year later" (B-C-DCG, 1990); *New York Times*, September 2, 1992; N. Coch and M. Wolff, "Effects of Hurricane Hugo storm surge in coastal South Carolina," *Journal of Coastal Research* 8 (1991): 201–26. The figures in the text are from the National Weather Service and NOAA sources, but the severity of Hurricane Hugo is a matter of dispute. The National Research Council of the National Academy of Science calculates Hurricane Hugo's wind speed at Charleston as only 70–80 miles per hour, barely a Category 1 hurricane. The 137-mile-per-hour wind recorded at Charleston is dismissed as inaccurate because the measurement lasted only a second and was taken from atop a vessel at the navy base in North Charleston. Richard Shenot, director of the National Weather Service in Charleston in 1989, stated, "Charleston did not experience a Category 3 or anything like it." South Carolina state climatologist Mike Helfert said that "Hugo was closer to a tropical storm in intensity." Editorial, "Wimp with Wallop: Scientists Reassess Strength of Hugo," *Beaufort Gazette*, July 29, 2000; "Hugo Was a Wimp at Charleston, Scientists Warn," *Post and Courier*, July 25, 2000. As of 2006, Hugo is the sixth costliest tropical cyclone. http://www.nhc.noaa.gov/Deadliest_Costliest.shtml?text.

Chapter III

34. Hugo Shorts, narrative to accompany slide presentation of the 1989 operations of the Charleston County Emergency Operations Center, files, CCEPD.

35. S.C. Code; Minutes of Charleston County Council, February 3, 1987, 9; Code of Sullivan's Island; Sullivan's Island Emergency and Disaster Evacuation Plan, October 24, 1977; Minutes of the Sullivan's Island Town Council, September 5, 1989, files, SI.

36. Interviews; After-Action Report, SCARNG; SCARNG Press Release No. 891104; *Post-Courier/The Evening Post*, September 21, 1989.

37. Hugo Shorts, Charleston County Emergency Management Division; Eric Frazier, "Evacuation resulted in traffic congestion," *Post-Courier*, September 21, 1989.

38. Andy Solomon, "Hurricane Hugo Series: One Man's Burden," ilovemountpleasant.com/onemansburden.php.

39. Interviews; "Islanders," *Post-Courier/The Evening Post*, September 21, 1989.

40. News and Courier/ Evening Post, *And HUGO was his name*, 15–17; interview.

41. Interview, Curtis Brice, Resident Maintenance Engineer for Bridges, South Carolina Department of Transportation.

42. Interviews.

43. Charleston District, U.S. Army Corps of Engineers, After-Action Report; Ben Sawyer Bridge Disaster Response, October 1989, files, Emergency Management Division, Charleston District, U.S. Army Corps of Engineers.

44. Interviews; Hugo Shorts, files, CCEPD; News and Courier/ Evening Post, *And HUGO was his name*, 6.

45. Steve Mullins and John Burbage, "Hurricane evacuees ordered

to stay put," *Post-Courier/Evening Post*, September 23, 1989; Willard Strong, "National guard to help area," *Post-Courier/Evening Post*, September 23, 1989.

46. After-Action Report, SCARNG.

47. dougsimpson.com/blog/archives/000468.html; Schuyler Kropf, "Officials grade disaster response 'low B,'" *Post-Courier/Evening Post*, September 23, 1990.

48. Interviews.

49. *News and Courier*, May 2, 1990; James Lee Witt, interview on *FRONTLINE*, September 16, 2005, pbs.org/wgbh/pages/frontline/storm/interviews/witt.html.

50. The helicopter was from the 659th Medical Detachment of the South Carolina Air National Guard and also ferried Guardsmen to Folly Beach, the Isle of Palms and Sullivan's Island. Willard Strong, *Post-Courier/Evening Post*, September 23, 1989.

51. *Post-Courier/Evening Post*, September 22, 1989; September 23, 1989; September 25, 1989; News and Courier/Evening Post, *And HUGO was his name*, 15, 17.

52. *Post-Courier/Evening Post*, September 23, 1989; September 25, 1989; September 26, 1989.

53. Susan Taylor Martin, "In the eye of the hurricane."

54. Interviews; Arlie Porter, "Palms mayor a no-show at meeting," *Post-Courier/Evening Post*, September 25, 1989.

55. Interviews; *Post-Courier/Evening Post*, September 25, 1989.

56. Interviews; Eric Frazier and David Quick, "Sullivan's officials refuse to rush visits," *Post-Courier/Evening Post*, September 25, 1989.

57. Interviews; *Post-Courier/Evening Post*, September 26, 1989.

58. Schuyler Kropf and David Quick, *Post-Courier/Evening Post*, September 26, 1989; September 27, 1989.

59. E.M. Kelly Jr., U.S. Military and Disaster Response (Carlisle, PA: U.S. Army War College, 1992), National Technical Information Service AD-A250-913.

60. References to the studies making these points may be found in Jamie W. Moore and Dorothy P. Moore, *The Hurricane Hugo Experience: The First Nine Months* (Boulder: University of Colorado, Natural Hazards Research and Applications Information Center, Institute of Behavioral Science Working Paper No.81), 6.

61. How people felt about the decisions of the town government and how strongly these feelings were held were also significantly influenced by age, how long one had lived on the island, the number of family members in residence at the time of the storm, sex, the amount of property damage and marital status, but not by the amount of damage to the property or the length of time the residence could not be occupied. Moore and Moore, *The Hurricane Hugo Experience*, 31–35.

62. Bill Steiger, "I'm not leaving next time around," *Post-Courier*, September 23, 1990; Town of Sullivan's Island, Sullivan's Island Disaster Plan, September 1990; Hurricane Preparedness Guide, 2005, 12. The 1990 plan was drawn up by a committee chaired by then-Councilman Carl Smith. When it was presented to Charleston County disaster officials, it was accepted only as information.

Chapter IV

63. Commission on Engineering and Technical Systems, "Hurricane Hugo, Puerto Rico, the Virgin Islands, and Charleston, South Carolina, September 17–22, 1989" (National Academies Press), 1994, lab.nap.edu/openbook/0309044758/html/9.html; Interagency Hazard Mitigation Team Report In Response to the September 22, 1989, Disaster Declaration, State of South Carolina, FEMA-843-DR-SC, Prepared by the Region IV Interagency Hazard Mitigation Team; Hurricane Hugo After-Action Report, U.S. Department of the Interior, National Park Service, Fort Sumter National Monument, files, FSNM.

64. D. Brazell, "Hurricane Hugo Lays Down the Challenge," *South Carolina Palmetto Guard* 2 (1990), 1, 6; SCANG, SCARHG Press Release No. 890904.

65. Hurricane Hugo After-Action Report, U.S. Department of the Interior; *Post-Courier*, September 23, 1990. Some people were without electricity for two to three weeks before power was restored.

66. Interview. At the time, Rogers worked for P&E Electric of Lexington, South Carolina. He is currently a crew chief with Gregory Electric Company of Columbia, South Carolina.

67. Charleston District, U.S. Army Corps of Engineers, After-Action Report; Ben Sawyer Bridge Disaster Response, October 1989, files, EMDCDCOE; Hurricane Hugo After-Action Report, U.S. Department of the Interior; Jami Koontz, executive assistant to former U.S. Senator Ernest F. Hollings, e-mail message to authors, June 12, 2006.

68. After-Action Report, CDCOE.

69. Charleston Southern University Earthquake Education Center, http://www.csuniv.edu/version3/academics/earthquake/scearthquakebrochure.asp.

70. Jamie W. Moore and Dorothy P. Moore, *The Army Corps of Engineers and the Evolution of Federal Flood Plain Management Policy* (Boulder: University of Colorado, Institute of Behavioral Science, 1989), 72–75.

71. "Building Codes and Standards," files. FSNM.

72. Jamie Thomas, "Flood Zone Home Violations Probed on Sullivan's Island," *News and Courier*, August 18, 1982; "Sullivan's Submits Building List," *News and Courier*, December 4, 1982.

73. Commission on Engineering and Technical Systems, "Hurricane Hugo, Puerto Rico, the Virgin Islands, and Charleston, South Carolina, September 17–22, 1989"; Hannah Heyward and Chris Sosnowski, "Codes basically sound, but fine-tuning needed," *News and Courier*, October 29, 1989.

Chapter V

74. Sources for the discussion of the insurance industry in this chapter may be found in Dorothy P. Moore and Jamie W. Moore, "Insurance Company Effectiveness Under Extreme Conditions: Lessons from a Consumer Test," *Group and Organization Management* 20 no. 3 (1995): 355–80.

75. M.P. McQueen, "Who Needs a Flood Policy?" T*he Wall Street Journal*, May 6–7, 2006.

76. Full disclosure. At the time of Hurricane Hugo, the authors had State Farm homeowners' insurance coverage on their residence and the separate flood policy covering flood damage to the dwelling and its contents. Several years later, State Farm dropped coverage for all houses built on pilings nationwide. As the Sullivan's Island building code requires the house be elevated, the authors purchased coverage from the Nationwide Group. Other than this, the authors have no relationships with any insurance carrier.

77. Michelle Higgins, "America's Priciest Getaways," *New York Times*, September 9, 2005.

78. Charleston Southern University Earthquake Education Center.

Chapter VI

79. Hurricane Hugo After-Action Report, NPS, files FSNM; Interviews.

80. For a complete list of the citations to the discussion of stress in this chapter see Dorothy P. Moore and Jamie W. Moore, "Post Hurricane Burnout—An Island Township's Experience," *Environment and Behavior* 28 no. 1 (January 1996): 134–55.

Chapter VII

81. Jamie W. Moore, "The Ashley and Cooper Rivers," in *The Rolling Rivers, An Encyclopedia of America's Rivers*, ed. Richard A. Bartlett (New York: McGraw-Hill, 1984), 10–13.

82. Hugo Shorts, CCEPD; Eric Frazier, "Evacuation resulted in traffic congestion," *Post-Courier/Evening Post*, September 21, 1989.

83. USACOE, "Hurricane Floyd 1999 Behavioral Studies." http://chps.sam.usace.army.mil/USHESdata/Assessments/Floyd/Behavioral/hurricane_floyd_1999_behavioral_.htm; cnn.com/WEATHER/9909/14/floyd.07/; John H. Tibbetts, "Floyd Follies: What We've Learned," *Coastal Heritage* 17 no. 1 (summer 2002), scseagrant.org/library/library_coaher_sum02.htm.

84. Kirstin Dow and Susan L. Cutter, "Emerging Hurricane Evacuation Issues: Hurricane Floyd and South Carolina," *Natural Hazards Review* 3 no. 1 (February 2002): 12–18, scitation.aip.org/getabs/servlet/GetabsServlet?prog=normal&id=NHREFO000000 3000001000012000001&idtype=cvips&gifs=yes; Kirstin Dow and Avagene Moore, "Learning from the Hurricane Floyd Evacuation in South Carolina," Edited Version of September 13, 2000 Transcript, EIIP Virtual Forum Presentation, emforum.org/vlibrary/lc000913.htm.

85. USACOE "Hurricane Floyd 1999 Behavioral Studies"; John H. Tibbetts, "Floyd Follies."

86. Executive Summary, Southeast United States Hurricane Evacuation Traffic Study, http://216.205.76.112/Reports/Executive_Summary.htm; Tibbetts, "Floyd Follies"; COE, "Hurricane Floyd 1999 Behavioral Studies."

87. Census 2000 PHC-T-3, Ranking Tables for Metropolitan Areas: 1990 and 2000. Table 1: Metropolitan Areas and their Geographic Components in Alphabetic Sort, 1990 and 2000 Population, and

Numeric and Percent Population Change: 1990 to 2000, U.S. Census Bureau, Census 2000 Redistricting Data (P.L. 94-171) Summary File and 1990 Census. Internet release date: April 2, 2001.

88. Executive Summary, Southeast United States Hurricane Evacuation Traffic Study.

89. Growth estimates are from epodunk.com/cgi-bin/genInfo. php?locIndex=13091, 13062, 13131.

90. Speeds are computed from the commuting data in Warren Wise, "Trapped in Traffic" (with Adam Parker, Jamie McGee, Chris Dixon, Jessica Vanegeren, Yvonne M. Wegner and Bo Petersen), *Post and Courier*, May 10, 2006.

91. Dow and Cutter, "Emerging Hurricane Evacuation Issues."

92. Yiping Han, Wei Liu and Hang Yu, "What If Another Floyd?" www.ic.sunysb.edu/Stu/yihan/papers/MCM/I2001/Article.pdf.

93. The two are members of different political parties: Riley, a Democrat, and Fava, a Republican.

Appendix I

94. For sources see Moore and Moore, *The Hurricane Hugo Experience*, 3.

95. M.J. Roszkowski and A.G. Bean, "Believe it or Not! Longer Questionnaires Have Lower Response Rates," *Journal of Business and Psychology* no. 4 (1990): 495–509. The study found that lower response rates are not necessarily biased, that while mail questionnaire length and response rates tend to be inversely proportional, the relationship is not necessarily conclusive and that differences between the short and long questionnaire returns are greatest when a long form places a significantly greater burden on the respondent rather than the length of the survey questionnaire.

96. For sources see Moore and Moore, *The Hurricane Hugo Experience*, 6.

97. For sources for the discussion of stress see Moore and Moore "Post Hurricane Burnout."

98. H. Freudenberger and G. Richelson, *Burnout, the High Cost of Achievement* (New York: Doubleday, 1980).

99. T.H. Holmes and R.H. Rae, "The Social Readjustment Rating Scale," *Journal of Psychosomatic Research* 11 (1967): 213–18. The scores were computed with unweighted life-event scales. Zimmerman (1983) found in an intensive comparison of weighted and unweighted scales that either method provided an equally good predictor of the stress-illness relationship. See M. Zimmerman, "Weighted versus Unweighted Life Event Scores: Is There a Difference?" *Journal of Human Stress* (December 1983): 30–35.

100. References, justifications and the development of scales may be found in Moore and Moore, "Insurance Company Effectiveness."

101. R.B. Chase and R.H. Hayes, "Beefing up Operations in Service Firms," *Sloan Management Review* 33 (1991): 15–26.

ABOUT THE AUTHORS

Jamie Wallace Moore, emeritus professor of history at The Citadel, completed his PhD at the University of North Carolina-Chapel Hill. He is the author of four books and more than eighty professional articles and papers, a former member of the United States Department of the Army Historical Advisory Committee and a past president of the South Carolina Historical Association. His most recent book, *Growing Up in Davie County: Reflections From One Hundred Years Ago*, was a finalist in the 2006 *ForeWord Magazine* Book-of-the-Year Awards.

Photograph by Jack Alterman

Dorothy Perrin Moore completed her PhD at the University of South Carolina. Her numerous awards include the Academy of Management's Women in Management Division's Sage Scholarship Award. A Fellow in the United States Association of Small Business and Entrepreneurship, her most recent book, *Careerpreneurs: Lessons from Leading Women Entrepreneurs on Building A Career Without Boundaries*, received the 2000 *ForeWord Magazine* Gold Award in the field of business. An emeritus professor of business administration at The Citadel, where she held the title of Distinguished Professor of Entrepreneurship, she will join the faculty in the School of Management and Entrepreneurship at the College of Charleston in 2006 to help establish the new program in women's entrepreneurship.

Photograph by Jack Alterman